THE GOSPEL ACCORDING TO THE WIZ

THE GOSPEL
ACCORDING TO THE

AND OTHER SERMONS
FROM CINEMA

OTIS MOSS III

THE PILGRIM PRESS
CLEVELAND

This project could not have been possible without the love, support, encouragement, prayers, patience, and humor of my wife and friend, Monica Moss. Thank you for putting up with my endless talk about movies, theology, and popular culture.

The Pilgrim Press, 700 Prospect Avenue, Cleveland, Ohio 44115
thepilgrimpress.com
© 2014 by Otis Moss III

Printed in the United States of America on acid-free paper

18 17 16 15 14 5 4 3 2 1

A catalog record for this book is available from the Library of Congress
ISBN: 978-0-8298-1991-5

CONTENTS

INTRODUCTION

❀

I am not sure when it happened. It could have been when my Uncle Ron took me to see *Alien* as a kid, and I was overwhelmed by the power of this art form to transport and terrify. Maybe it was my father's love of all things James Bond and historical. We would sit in the family room night after night watching the *7 Days of Bond* on WTBS. I wonder if it was the night I was dragged into the theater to see a film entitled *Gandhi* and walked out transformed, wanting to know more about this amazing human being.

It is also possible that it happened during the yearly holiday ritual of watching *The Godfather* with my family and friends and being cap-tivated by the mix of religious ritual and stylized street thuggery. Whenever the moment happened, I became captivated by film as an art form, cultural marker, and religious lens for discerning the ethos of our culture.

Many will read this collection of sermons and shudder. Why would a preacher, steeped in the world of faith and ritual, engage such secular texts to teach and preach? I first must share my theological grounding. As a person of African descent who is deeply informed by Africanized motifs from the U.S. South that flow from the black

church and West Africa, traditional modalities of sacred and secular are disrupting. According to scholar John Mbiti, African spirituality does not recognize sacred and secular demarcations. All life is connected to God and all cultural productions—music, dance, and art—are gifts from God. Gospel music, the standard bearer of religious inspired folk music, is an amalgamation of blues chords and structure. Jazz and the blues inform and serve as a catalyst for gospel music. I mention this because art, when authentic, creative, and created from the deep wellspring of humanity, speaks to spirituality.

The works of Flannery O'Connor, William Faulkner, August Wilson, Zora Neale Hurston, Jacob Lawrence, Junot Díaz, and Toni Morrison all raise spiritual questions and incorporate religious themes in the text. Martin Scorsese, Francis Ford Coppola, Steve McQueen, Julie Dash, Kasi Lemmons, and Spike Lee all address questions of identity, grace, forgiveness, love, sin, and redemption.

The biblical themes of love, redemption, grace, sin, hope, and trust are present in all great art. It is hard, in the Western context, to be released from the power of these themes introduced to many by biblical characters in stories. Through a biblical lens *The Godfather* is a retelling of the Shakespearean story of Macbeth and the Davidic story of David and his sons. *The Matrix* is a modern retelling of the Christ narrative. *The Book of Eli* uses fragments of John the Baptist and the Prophet Elijah to create a postapocalyptic parable. *Avatar* is a classic quest and call narrative mixed with anticolonial themes.

Movies, in the hands of gifted auteurs, have the ability to do more than entertain. They inspire, inform, and force us to reexamine our relationship to the world. Movies have always been a big part of my life. I thought I was called to be a cinematographer at the age of thirteen, and I spent the next four years studying the craft and making (bad!) actions films with my friends. I worked as an editor for a local television station at age sixteen and went to Morehouse College expecting to major in Mass Communications and eventually attend New York University's Tisch School of the Arts and become a film-

maker. God had other plans, but I never lost my love of film as a powerful medium to teach and inspire.

If you think about it, sports arenas and movie theaters are the modern cathedrals. Where else, outside of the church, do we gather for a shared experience and are not bothered by the outburst and shouts of neighbors? Any person wanting to connect on a first date always asks about movies, music, sports, and food.

Movie references are the language for cultural competency in America. It is not possible to fully engage any television show or understand a comic reference unless your cultural competency is sufficient to make the connection between the reference, irony, and punch line of the comedian.

Collected in this volume are messages with cinematic titles and themes. What you cannot experience through the written word is how these messages were created. A talented team of men and women at Trinity United Church of Christ sit down every Tuesday to map out worship. It was the vision of the pastor to create a 360° model of worship, and "360°" was developed as a term used to describe the multiple ways people learn. Every congregation has a population that is oral, visual, tactile, visceral, intellectual, and narrative-based. Only fully immersive worship can accomplish the goal of reaching this diverse group of people. The team is the engine to create the atmosphere for the message to be preached in a 360° motif. Our multimedia team designs images to fit with the message. The music ministry seeks to connect musically with the theme of the day. The dance and drama teams choreograph and produce movement characters to support the message. Even our set creator reshapes the narthex or sanctuary to transport the congregation to Africa or to highlight the struggles of the 1960s.

This may sound strange to some reading these pages, but liturgical forms from the Roman Catholic Church and the Ethiopian Orthodox Church use the same method. Art, icons, and stained glass are used to transport the worshiper to a certain era or state of mind. Music and

incense seek to arouse the senses. The dress of the Ethiopian priests speaks to the theology and culture of the community. Unfortunately, you will not be able to witness the full weight of the messages in this book, since they are designed to be experienced, not just heard or read. However, some of the sermons can be viewed by searching YouTube for the sermon title or for "Otis Moss III."

In the sermon "The Gospel according to *The Wiz*: The Miseducation of the Scarecrow," the drama ministry actor representing the scarecrow entered the pulpit as I closed the message, and I literally pulled the scripture quotes from the scarecrow. The Word was being pulled from the mind and heart of the scarecrow. This illustrates the need to have the Word in our spirit ready and available to encourage, teach, nurture, and empower God's people. The sermon "The Gospel according to *For Colored Girls*" that I delivered at Trinity began with several talented young women performing parts of the original play, or choreopoem, that the film was based on as the lead-in to the sermon. Although this dramatic, performed introduction has not been included in this book, replaced by a synopsis of the content, the message deals with the difficult topic of rape. *The Butler* message is connected to a cadre of characters, "unsung heroes" of African American history, who made a grand and powerful entrance into the sanctuary at the close of the message. The message of *Avatar* lifts up the traditions of West African people who were wiped out by colonialism, and their ancestors showed up at Trinity as part of the sermon. These messages are not preached alone, but with a team with one goal in mind, to communicate the Gospel to the unchurched community and the churched population of Trinity United Church of Christ. It is a high honor to serve at Trinity United Church of Christ and a double privilege to work with a gifted crew of worship leaders.

I pray that this volume will inspire and inform you to view film, faith, and the Bible from a different perspective. It is my prayer that you will view cinema as a popular cultural text to engage an unchurched population desperately seeking a spiritual center. I pray

that your experience with these messages will inform and uplift you in a manner that will enable you to engage film and popular culture in new, exciting, and creative ways. May God bless you and keep you. I thank you for taking a moment to peek behind the veil of 360° worship. I hope to see you at the movies and at Trinity United Church of Christ, and I wish for you the blessing of imagination.

ONE

THE GOSPEL ACCORDING TO THE WIZ

I'm Ready to Get Out of Oz

❀

SCRIPTURE: RUTH 1:1–7

If you have your blueprint for salvation, the guide upon our journey, the rudder of our ship—your Bible—I would kindly ask that you would turn to the first chapter in the Book of Ruth. It reads this way from the New International Version, beginning with verse 1:

> In the days when the judges ruled, there was a famine in the land and a man from Bethlehem in Judah, together with his wife and two sons, went to live for a while in the country in Moab. The man's name was Elimelech, his wife's name was Naomi, and the names of his two sons were Mahlon and Kilion. They were Ephrathites from Bethlehem, Judah. And they went to Moab and lived there.
>
> Now Elimelech, Naomi's husband, died, and she was left with her two sons. They married Moabite women, one named Orpah, and the other Ruth. After they had lived there about ten years, both Mahlon and Kilion also died, and Naomi was left without her two sons and her husband.

When Naomi heard in Moab that the LORD had come to the aid of his people by providing food for them, Naomi and her daughters-in-law prepared to return home from there. With her two daughters-in-law, she left the place where she had been living and set out on the road that would take them back to the land of Judah.

Another translation could be: "with her two daughters, she left the place where she had been living and decided to ease on down the road that would take them back to the land of Judah." May the Lord add a blessing to the reading and hearing of God's Holy Word. I would like to place a tag upon this text, for it constitutes the context of which we will attempt to teach and to preach. For the next several Sundays we are in a series entitled "the Gospel according to *The Wiz*," but I would like us today to focus upon the subheading "I am ready to get out of Oz."

Beloved, I invite all of us this morning, this day, this afternoon, and for the next several weeks to take a journey down familiar biblical territory using a familiar and famous secular story. This story, *The Wiz*, is the African American version of a literary classic by L. Frank Baum entitled *The Wonderful Wizard of Oz*, which was made into the famous film *The Wizard of Oz*. *The Wiz* was originally a Broadway production with music by a gentleman, now gone, by the name of Charles Small, a brilliant composer, who died at the age of forty-three as a result of a ruptured appendix.

The Wiz on Broadway in 1975 starred two actresses, unknown at that time, who eventually went on to become great rhythm-and-blues and jazz divas. One actress was Stephanie Mills. The other—who became a great jazz artist—was Dee Dee Bridgewater. Following the success of this particular stage production, the musical was later turned into a film produced by Motown and starring Diana Ross, Michael Jackson, and Nipsey Russell, with guest appearances by two unique legends—Lena Horne and Richard Pryor.

Both the 1939 movie *The Wizard of Oz* and the more recent film adaptation *The Wiz* are more than musical entertainment. Both films are about discovery and a protagonist's journey to reach her destiny. I submit to you that this film juxtaposed to the Bible helps us illuminate a variety of theological insights about human nature. It is in this text that we witness a literary juxtaposition that segues into the cinematic world of Oz and gives us a biblical understanding of Moab.

The Book of Ruth in the Old Testament, the book named after a woman, breaks into the patriarchal boys' club and makes space for a sister. Ruth, if one looks closely, has some of the same issues as Dorothy in Oz. Obviously both Ruth and Dorothy are women. Both are from minority groups—one from Moab, the other a black woman, a sister. Both are caught in a storm—one a famine, the other a windstorm that takes her to Oz. Each of them has been displaced from family and each is forced to go on a journey in order to reach her destiny.

Their stories coincide and collide. Ruth's life is turned upside down by a "storm" of sorts, a famine. It says right in the text that there was a famine in the land—and this was not an act of punishment, as some theologically think; we do not know how this famine started. But if one looks sociologically and historically, one understands that famine is a result of two things in the world. A famine can happen because of natural disaster. Rain refuses to fall and therefore the crops cannot grow. Or a famine can happen as a result of political folly.

Famine always follows a war, because that is when there is an economic downturn. A famine occurs when domestic issues are neglected and foreign affairs become higher on the agenda of the person or persons in power. Every war throughout history has always had a famine associated with it. No matter what war any country has ever entered into, a resulting famine has always affected the poorest of the poor. A war-related recession is sure to hit those who are in need, and no matter when a country goes to war, a famine follows.

When governments direct resources into war instead of education, jobs, health care, supporting the poor, elderly, roads, and small

businesses, a famine will always follow; and historically persons who lead the country into war are often not around when the ensuing famine starts. Ruth and Naomi are upended by a storm and find themselves in Oz, a world turned upside down. It looks familiar, but the landscape is desolate, barren because of the storm. Roger Connors in his book *The Oz Principle* states that Oz is not a physical place, but a state of mind.

Whenever a storm upends your life, you are living in Oz. Whenever you lose a loved one, experience the shock of losing your job, are going through some trauma—you are living in Oz. When you don't have two nickels to rub together, your money is funny, and your change is strange, you are living in Oz. Everything may look familiar, but because you're in Oz, things are incredibly different. You are living in Oz.

You know that you are in Oz when you repeat that famous line Dorothy delivers in the movie: "Toto, I don't think we're in Kansas anymore." The other thing one must understand is that no matter if you go to church every Sunday and have the biggest Bible in the community, there is going to be a moment in your life where you will experience Oz. A storm is going to show up at your door, take you, and displace you from your family. You will be disoriented and will not understand heads or tails or which way is up. I'm sorry to let you know, but we all will experience and visit Oz.

Don't act like you've never been to Oz. Or, if you haven't yet, just keep on living, baby! You will experience Oz in your life. Somebody will get sick. Somebody will die. There will be some heartache and some pain in your life. A storm is coming to your door. If you act like there will be no storm in your life, wait fifteen minutes. A storm will show up in your life and you will live in Oz.

But consider this—not only will we experience Oz, but many, many of our young people are already in Oz and have been in Oz for quite some time. Consider, for instance, all of the mass incarceration in our community where young men of color are filling up the jails; they are living in Oz. When you look at the graduation rate of African

American boys, which is only 50 percent, you can see that we're living in Oz. When you see that it was more likely for a child of color to have both parents in the house during slavery than today, then we are living in Oz. I'm here to tell you, don't think just because we have somebody who looks like us in the White House that Oz is not operating in our community. This is not a postracial situation. This is a situation where we are living in Oz.

Ruth and Naomi are women living in Oz. They are poor; they are without husbands. For a woman in the biblical time period, it's one thing for your husband to die, but then for your sons to also die is much worse, because your identity is connected to a man. The fact that an entire book is named after a woman who may come from an Oz, from a foreign country, from a famine situation, is a powerful narrative that God moves beyond our own patriarchal patterns of how we think the world should operate. Ruth and Naomi are women living in Oz, and this particular text gives us some idea as to how one can get out of Oz. You may ask, "How do I handle my Oz?"

I'm glad you asked that question because I believe in this text we have some information as to how to get out of your Oz, your negative life situation. It is something very simple. It is right there in the text, but it's also in the movie; you will notice that if you want to get out of your Oz situation, you have to learn how to survive your Oz. In order to survive your Oz, you have to make sure you have the right companions. Dorothy had Toto. I like Toto; Toto's my man. Toto rolls with Dorothy and says, "I am with you to the end. If somebody jumps bad with you, I'm jumping bad with them."

Why is Toto so loyal to Dorothy? Dorothy was good to Toto and so Toto said, "I'm going to protect Dorothy. If it's a lion, I'll bite his tail. If it's a flying monkey, I'll chase him out of the way. I'm not scared. Why? Because I'm rolling with you, Dorothy."

Here you have Ruth and Naomi in the midst of an Oz experience and Ruth says, "You know what? I am not going anywhere, Naomi. I know that you lost your husband, yes, and you lost your sons, including

my own husband, but I am walking with you. Your God will be my God. Your country will be my country. Wherever you go, I'm going to roll with you. I am down with you wherever you are."

When you go through your own storm, your Oz, you do not need fickle people around you. You need people who are going to walk with you. You need a Toto who is going to be down with you. You need somebody who is going to pray with you and support you. I know that some of you have been through a storm, have been through an Oz-like experience, and you are thankful you had somebody who was sticking right by you.

You need somebody, the right companion, when you are going through your Oz, and so we see in the text that Ruth and Naomi are rolling with each other. I like Ruth because Ruth says, "Look here, I married into your family and you loved me, Naomi. You treated me as your own daughter. There is nothing back there in Moab for me. There is nothing but family. I'm going to go wherever you go because your God has been good to you even though we are in the midst of a famine." But you have to see what is also in the text that I love—it says here that Ruth and Naomi are rolling together. Ruth and Naomi are now friends. They are daughter and mother.

You really have two different generations—Naomi, who is a seasoned saint, and Ruth, who is a young sister. You have a grandparent and someone from the child or even grandchild generation. You have someone who is an elder who has a lot of wisdom, and then you have someone who is from a younger generation who has a lot of energy. When God brings two different generations together, God will bring wisdom and energy together, and when wisdom and energy get together, then the world can be turned upside down. There are some people in your generation who are your peers who can't do anything for you. You need to find someone who is a seasoned saint.

Why do you need to find a seasoned saint? Because seasoned saints have been through some stuff already. They know how good God is, that God will open up doors that no one can shut. Your peers

can't do that for you. You need somebody who has already walked the road you are walking and who can remind you, "Baby, God might not come when you want him, but God's always right on time." You need someone to remind you that God can hit a straight lick with a crooked stick. You need somebody to remind you that if human praises go up, then blessings come down.

You need to have the right companion. That's why there need to be elders and young people together. You also need somebody of a different generation walking with you so that you are not always in the same *modus operandi* that you have been in. You need to operate in a different manner. You need someone to energize you, to let you know that God is not through with you yet, Grandma. God's not through with you yet, Grandpa, and when you put these two generations together, they can turn the world upside down.

Have you ever had a companion in your life, a seasoned saint, who knew how to encourage you unlike anybody else? When you were down, this person could call you, press pennies into your hand and say, "Baby, you keep on moving. You just put one foot in front of the other and you keep on keeping on." You need somebody around you who is the right companion. And you have to be careful about the kind of companions that you have, because some people have been in Oz so long that they are used to Oz. You must understand that Oz is not your natural state, just as Naomi and Ruth understood that famine was not where they should be. You need to have people around you who are going the same place to which you're trying to go.

That's what happened in the movie *The Wiz*. Do you recall that when Dorothy comes into Oz, she meets a gentleman by the name of Scarecrow? You remember the scarecrow scene? Scarecrow played by Michael Jackson? He's hanging up there as a scarecrow and all these crows are around him. He's a scarecrow but can't scare any crows.

He is up there but can't scare the crows because the crows are telling him that he needs to know the crow commandments. He needs to sing the crow song. He can't win. That's the song he had to sing all

the time to let him know that he did not have any authority or power. Now the scarecrow's problem was that he always had people around him who wanted him to stay in the same position. You need to make sure that, when you are going where God is calling you to go, you have the right people around you, because you don't need any crows in your life, and you don't need folks telling you to stay put.

You need people who will let you know that God has called you to do great things. It's not until Dorothy shows up that the scarecrow comes down from that pole, and when he comes down, he says, "You know, I can't walk," and Dorothy says, "You are just a victim of negative thinking." She says, "I'm going to the wizard, and all we have to do is find the yellow brick road." It is the scarecrow who finds the yellow brick road, and then they sing that all you have to do is just ease on down the road. Put your left foot up and right foot down and ease on down the road.

The crows wanted Scarecrow to stay in the same position. Ah, but Dorothy helped him to move to another level. Sounds like another biblical character by the name of Job. Job had some so-called crows in his life who were trying to tell him that the reason he was suffering was because of something that he had done. You must make sure you have the right people around you. You need to have people who are willing to encourage you, people who are willing to pray with you. There are some people you need put aside who cannot walk the road that you are walking because they love Oz too much. They love their situation and their pity party too much, but you see that you are trying not to stay in Oz.

You're trying to get out of Oz, and people who are trying to get out of their situation need to make sure they are rolling with the right people. So we see that Ruth and Naomi are perfect companions for each other. But not only are they perfect companions. Here's a simple thing—one of the reasons that they are able to get out of their Oz situation is because Naomi makes a decision to leave. That's all she does. She says, "I am not staying here because I heard that God is doing

something over there." Naomi said, "I haven't been there yet, but I heard that God was doing something over there." How did you hear, Naomi? Well, I heard from somebody who heard from somebody who heard from somebody that God was doing something over there and it is better to at least move from here to go there than stay here. Because here I know I'm going to die, but if I go over there, maybe I'll die, but I would rather move and see the possibilities. You must make the decision that you see needs to be made if you want a better life. You have to make a decision.

If you want your child to do well, you must make a decision. If you want your marriage to do well, you must make a decision. You have to make some decisions in your life and stop having a personal pity party about everything going on in your situation. Make a decision to say, "I am getting out of Oz because staying is not an option." You can't stay in Oz. Part of our community's challenge is that we have so many young people who are living in Oz, because, believe me, if you smoke enough blunts, you will stay in Oz.

For those who do not know what blunts are, that's marijuana, and we have young people in our community who want to stay in Oz. But it is time for us to get out of Oz, and we need to help our young people to get out of their comfort zone, because there are some crows in their classroom that will try to tell them when they make the right decisions that they are "acting white."

Are you out of your mind? I'm not acting white when I get an A or a B in school. I'm acting as a child of God, because God has already determined that I am intelligent. God has already determined that I have great gifts. Are you crazy? Do you think intelligence operates out of a genetic requirement? Absolutely not. God has done something already in my mind. We have to help our children get out of Oz, but part of the problem is that we have parents who like living in Oz.

You need to get out of Oz. It is time to grow up, parents. I'm talking to you now. Sisters, I am telling you that twenty years ago that dress didn't fit and it is not going to fit today. Get out of Oz. Brothers,

wearing a muscle shirt . . . (notice that phrase has the adjective "muscle" in it), don't put on that muscle shirt and be the old guy in the club. Get out of Oz. God has called you to something greater.

Not only are our children in Oz and our parents in Oz, but the church is in Oz. Some churches are around trying to make preachers rich so they can drive big old Bentleys. Are you out of your mind? God did not call us for that. God called us to transform the world, and here they are turning the church into their own personal club. They must be out of their minds. Get out of Oz. I'm talking about those who say, "God's going to bless me with a house and God's going to bless me with a car." What we need to understand is that our blessings are not material. A material benefit is the *residue* of the blessing. That is not the blessing. That is the residue of the blessing. The real blessing is your relationship with God. Because that Bentley is going to break down. That outfit you have, you will not be able to wear in another year. You can lose the car, lose the house, lose your coat, lose your job . . . but you will still have Jesus. You will still have joy, and this joy you have—the world did not give it and the world cannot take it away.

Are you ready to get out of Oz? We are getting out of Oz today. You can stay in Oz if you want to, but I know there are at least a few people who are sick and tired of being sick and tired and who are ready to step out of their storm and step into their destiny. With God, you can do what God has called you to do. You need to ease on down the road. In other words, trust in the Lord with all thy heart. Lean not onto thine own understanding, and God will make your path straight. It's time to get out of Oz.

Some of you have been in Oz so long that when you make it home you still have desires to get back to Oz, because in Oz you don't have to accept responsibility; in Oz you can blame everything on witches and wizards. When you get out of Oz, you've got to take some responsibility, and there must be some accountability. When you get out of Oz, you cannot blame your troubles on the flying monkeys. When you get out of Oz, you cannot blame them on the wicked

witch. When you get out of Oz, you cannot blame everything on the wizard. But understand this—Dorothy and company were looking for a man who was called the Wiz. They thought he was going to solve all their problems.

There is no wizard around here. No wizard is going to solve your problems. You better learn how to click your own heels so you can make your way home and do what God is calling you to do. You must have something else. You must make it out of Oz, but there's another thought. Let's sum up: (1) You must understand that you have to have the right people with you, the right companions, absolutely, when you're in Oz, and (2) you have to make the decision to leave Oz. But here is the other thing: Never waste a good storm. The storm in Ruth and Naomi's life was a famine, but if there had been no storm, Ruth would have never met Boaz. The storm put her on the path to meet brother Boaz, and brother Boaz was no ordinary brother. Not only was Boaz handsome, he also had a job, but I am not just talking about a job. Boaz owned the field. He owned property. He was paid. If you read Ruth, you will notice that Ruth comes into the city and speaks to the person who is managing the field. She says, "Is it all right if I come out here just to glean some food because I'm taking care of my mama?" The brother says, "All right, you can do that, but this field is owned by Mr. Boaz." No problem. So Ruth goes home and puts on her best outfit, just in case.

She wasn't looking for anybody, but you know, she's a sister, and whenever she goes out, she has to look right. And so she is not looking for a brother. She is just out there minding her own business, doing her thing, and here comes Boaz checking out his field.

He wants to find out "Who is this in my field?" He wants to find out her name, so he walks on over to Ms. Ruth and says, "Hi, I'm Boaz. I own this entire field. All of the brothers here work for me. I am the man in this country, and who might you be, young lady?" And Boaz ends up raising Ruth's and Naomi's status. As a result of the famine, Ruth and Naomi end up on a path where they are elevated to a whole other level. You need to understand that you never waste a good storm.

God is not trying to mess you up. God is trying to set you up. God is not trying to destroy you. God is trying to develop you.

Consider Noah. Noah was in a storm, but he ended up saving humanity. Joseph was in a storm, and he moved to second in command in Egypt. Moses was in a storm when they tried to destroy all the first-born sons, and he became the liberator of his people. Deborah was in a storm, and she ended up becoming a judge. David was in a storm, and he ended up writing the Psalms. Jesus was in a storm and he ended up saving the entire world. God will use your storm. Let me explain it like this so you understand what I am trying to say.

Years ago when a company was attempting to ship codfish from Boston all the way out to the West Coast, there was a problem: Every time a codfish arrived in Boston, the company tried to freeze it first, but they later discovered that the codfish did not have any flavor. The fish lost its flavor after they froze it. Then someone said, well, why don't we just send the codfish in a fish tank and let them swim around for several days and, when they get to California, they will be nice and fresh. So they tried this; however, when they shipped the live fish out to California before processing them, the fish was mushy. The fish tasted nasty.

They were trying to figure out why the fish was so nasty. It had no flavor. The live fish almost looked like they were dead by the time they got to California; they would just kind of float in the tank. Finally someone in Boston had this brilliant idea: Why not put the cod's natural enemy in the tank? So they dropped some catfish (catfish can be kind of mean) into the tank, and then shipped the tank out to California. The catfish in the tank chased the codfish for several days.

So the codfish were swimming and the catfish were chasing. Now, if you were to talk to the codfish, they might be saying, "Are you trying to destroy me by putting some catfish in here?" However, as the codfish were swimming around the tank, they were working their muscles in the process. Even though (or we might say because) there was an enemy in the tank, the codfish were being strengthened and the codfish were sweeter when they got to California than when they had nothing

chasing them. Sometimes God will put you in a storm to strengthen your muscles, and when you come out of the tank, you will be spiritually buff because God has already done something in your life.

Maybe there was a storm in your life and the storm taught you how to pray. You have to thank God for the storm in your life because, if you had never had the storm, you would not know how to worship God. If you never had a storm, you would not know that God could open doors.

God can use your storm. God can transform you with a storm. If any church understands storms, it should be Trinity United Church of Christ. I was talking to somebody who asked me, "What happened with your church after your church went through what it went through?" [following the 2008 presidential election and the retirement of Rev. Jeremiah Wright]. I said, "We are doing pretty good, if you ask me. When I look, I see God doing amazing things." "But that's not possible," he said. We had a conversation during which this particular person said he felt that the church should be dead. Why did he think the church should be dead?

Well, (1) the pastor of thirty-six years retired. The church should be dead. And (2) the church got attacked as a result of a member becoming president. The church should be dead. Then (3) we had an economic downturn that should have destroyed the church. I do not understand how the storm didn't destroy you, this man said. Well, all I could say is that we didn't waste the storm.

Everything that was used to try to destroy us resulted in us coming out better on the other side because we found out that there is power in the name of Jesus, that Jesus still has authority, that Jesus still has power, that there is power in the name of Jesus. Don't waste your storm! This final thing I want to share with you: There's a song in the movie *The Wiz*, my favorite in the movie. Dorothy has to go and destroy the wicked witch. (Remember Evillene sang: "Don't Bring Me No Bad News.") Dorothy and friends destroy Evillene, the Wicked Witch of the West, and all of a sudden, the people start dancing.

Now wait a minute. They are still in Oz, but they're dancing as if they are out of Oz. Wait a minute, the people are still in Oz, but they're dancing like it's a brand new day. In the text about Ruth and Naomi, when they make the decision to leave Moab, the tenor of the text changes. Even though they're still poor, they're still women, they're still unmarried, they have no particular land rights, yet they are worshiping and operating as if God is going to do something in the future—they have premature praise.

Premature praise is praise for what God is going to do that causes you to dance like it's a brand new day. But wait a minute, you say, I'm still in yesterday. That's all right. If you are still alive and God woke you up yesterday, you need to get ready for your tomorrow and your next week. God has already prepared something for you, and it is a brand new day. I want you to know that God wants you to operate as if God is about to open up something amazing in your life. And when you know that God is on your side, you can dance in the midst of your Oz, even while knowing that you're still in Oz.

It is a brand new day, and God is about to tell everybody to rejoice. It is a brand new day, and God wants to let you know that this is the day that the Lord has made. It is a brand new day, and some things have been taken out of your life. It is a brand new day. God is about to bless some folks. It is a brand new day, and when you operate as if it is a brand new day, even though you are not out of Oz, you will be well on your way to moving into new territory.

REFLECTION QUESTIONS

1. Co-authors Roger Connors, Tom Smith, and Craig Hickman (*The Oz Principle: Getting Results through Individual and Organizational Accountability* [New York: Penguin Group, 2010]) state that "Oz" is not a physical place. It is a condition, circumstance, or situation. Describe a time you were in Oz. How did you get out of Oz and who helped you?

2. It is important to surround yourself with the "right" people. What qualities do the "right" people exhibit? Who are the "right" people in your life?

3. Naomi and Ruth demonstrate how different generations can support and affirm each other. Describe your relationship with someone of another generation. What are the joys of this relationship? What are the challenges?

4. Literal and figurative storms are a fact of life. What have you learned and gained from experiencing the storms in your life?

5. What have you done to help someone you know who was in "Oz"? What can the church do to support and help people who are in "Oz"?

TWO

THE GOSPEL ACCORDING TO *THE WIZ*

The Miseducation of the Scarecrow

f you have your blueprints for salvation, the guide upon our journey, the rudder of your ship, I would ask that you would turn to Romans 12, beginning with verse 2. I'll read the New International Version and the "OM3/Wiz" translation. Romans 12, verse 2, reads this way: "Do not conform any longer to the pattern of this world." Another translation directly from the Greek could be: "Do not conform any longer to the pattern of this age, but be transformed by the renewing of your mind. Then you will be able to test and approve what God's will is, God's good, pleasing, and perfect will."

Another translation, the OM3/Wiz translation, would read this way: "Do not conform any longer to what the crows are saying to you, but be transformed by the renewing of your mind. Then you will be able to test and approve what God's will is, God's good, pleasing, and perfect will." May the Lord add a blessing to the reading and hearing of God's Holy Word.

Beloved, I would venture to say that two of the most profound and powerful works of intellectual and academic rigor of the twentieth

century were written by two intellectual giants. One gentleman, now long gone, was Dr. Carter G. Woodson. Professor Woodson has two books I would urge every Trinitarian to get a copy of. Download them on your iPad, Kindle, or eReader. If you have children or grandchildren, make it a requirement that they read these before they obtain their driver's license or graduate from high school.

The first book Carter G. Woodson wrote that I would suggest everybody get a copy of is *The Mis-education of the Negro*. Another title that many people are not aware is a companion book entitled *The Education of the Negro Prior to 1861*. Those two books will help you understand our current condition probably better than many of the other academic books that have been written in the last twenty or thirty years.

The second intellectual giant is a gentleman by the name of W. E. B. Du Bois, one of the founders of the NAACP, a pan Africanist and an early feminist. His classic book that no library should be without and that every high school and college student should have a copy of is a text entitled *The Souls of Black Folk*.

Both intellectual giants, Du Bois and Woodson, discovered that, after emancipation, the question for Southerners and for antislavery Northerners alike was this: Do people kissed by nature's sun have the intellectual capacity to learn? Or are they simply mental infants, doomed to live a life of servitude?

Du Bois and Woodson both clearly state that education provided by the Freedman's Bureau and missionary schools failed to meet the needs of post–Civil War freed African slaves. After freed Africans were emancipated, there had to be a plan to deal with them. For those who may not be familiar, the Freedmen's Bureau was set up after the Emancipation Proclamation to provide schooling and housing for these freed Africans. Out of the Freedmen's Bureau came the idea of "forty acres and a mule." Many of the schools set up by the Freedmen's Bureau and northern missionaries unintentionally and intentionally miseducated people of African descent because of several fundamen-

tal flaws in their educational philosophy. Educational philosophy is what those in education call pedagogy.

The first flaw and wrong assumption they made that led to mis-education was that Africans were intellectual midgets and education designed to free the mind and emancipate the spirit would be of no value. While many held this belief, there were others in the South who believed that if you educated people of African descent, who were already skilled and intelligent, they would then take over the jobs that should go to poor white Southerners.

Because of emancipation and the fear of educated Africans, another organization was created just in case Africans were educated and ended up taking someone else's job. Therefore, in order to take their country back, whites created the KKK, the Ku Klux Klan. And that organization was specifically designed to make sure that people of African descent, after emancipation, would not be educated and threaten the class balance or infrastructure that had developed as a result of slavery.

Remember now, the people who were the blacksmiths were black folk. The people who were the metal workers were black folk. The people who knew agriculture were black people. The people who knew how to build homes were black people. The skilled labor of the South came from people of African descent. The first fundamental flaw of the Freedmen's Bureau was the idea that Africans were intellectual midgets or that their skills would replace those of poor whites. The second flawed assumption was that Africans never contributed any-thing to civilization. As a result of these flaws, those who taught people of African descent taught them as if they'd never existed in history. These two fundamental assumptions, taken together, produce some-thing negative in our own community.

When many people of African descent were educated, they did not necessarily in any way want to connect with their own community. They wanted to run as far as they could from anything that looked as though it might be connected in some way to being black. Those of African

descent whom Du Bois talks about comprised "the talented tenth," those who actually had a degree, wanted to have nothing to do with other people of African descent. They wanted to be more European than the Europeans, and it is Woodson who says this is the basis of miseducation. Education should illuminate. Education should free the mind. Education should not chain someone; instead education should set one free.

The Freedmen's Bureau and the missionary schools created a model of education that prepared men and women not to build their own communities, to develop their families, to contribute to democracy; rather, that education was designed—especially for Africans who stayed in the South—so that they could be better field hands. Students did not go to school for nine months, but instead went to school for only three months, because the majority of their time was spent picking cotton, even though they were free.

The Freedmen's Bureau and the the missionary schools designed education to help people of African descent be comfortable in the field, so that even though they had been released from the field, they would be educated only to deal with the field. The education system was designed to get them comfortable being in the field, staying in the field, hanging out in the field, living in the field, marrying in the field, just spending all of their time in the field because they would work for somebody else for the rest of their lives.

The education was designed to tell them that there is nothing beyond this field. There is nothing beyond this place. You must get it in your mind that you cannot look out beyond the field; that you must stay in this field for the rest of your life. Do not bother trying to leave the field, because you are to stay in the field.

And I must admit to you that, watching the film *The Wiz*, it dawned on me when I saw a particular character that there was a connection to our history, and the story was upon the screen. *The Wiz*, as you know, is based upon the play by Charles Small and the book by L. Frank Baum. *The Wiz* is the story of Dorothy, a young woman from Harlem, who is caught in a storm and transported to Oz. As a result

of her arrival in Oz, she liberates the munchkins, who had been captured by Evermean, sister of Evillene, the Wicked Witch of the West.

Dorothy is given silver slippers by the good witch Glinda and told that if she wants to get out of Oz she has to find the Wizard of Oz, who has the power to help her home. The only way to the Emerald City is by following a yellow brick road, and one just eases on down there. Once she is upon her journey, Dorothy stumbles upon a scarecrow, a scarecrow played with perfection by a young Michael Jackson—before *Off the Wall* and *Thriller*.

Dorothy stumbles upon this Michael Jackson as a scarecrow. His job is to stay in the field. The scarecrow works in the field, lives in the field, is never to leave the field. The scarecrow believes his purpose is only in the field. He does not own the field but works the field for somebody else. He has spent his entire life in the field.

Being a good scarecrow means that you keep your position of powerlessness. When you're a good scarecrow you stay in your position. When you're being a real good scarecrow, you keep the pole up your back. (I did say "back.") Yes, you keep the pole up your back and stay in your position and do not move.

And what is fascinating here is that, on a subconscious level, if you look at the picture on the cover of your bulletin, you will understand that the filmmakers wanted you to think about lynching or being on an auction block—on a subconscious level—when you saw the scarecrow. This isn't the scarecrow from the 1939 film *The Wizard of Oz*. This is the scarecrow from *The Wiz*, and it looks like he's on an auction block.

When Dorothy finds the scarecrow, we have no idea of his history. We don't know what scarecrow people have done throughout civilization. We don't know his background, but there's something we do know about the scarecrow in *The Wiz*. The only reason he's in his position is because he has crows around him. The crows want to keep him in the field. The only reason Scarecrow is still in the field is because of the crows.

Now let me say it at the outset: We all have crows in our life. And not every crow is black and not every crow is white. There are black crows. There are white crows. There are brown crows. There are yellow crows. There are brother crows. There are sister crows. Some of you dated crows. Some slept with crows. There are crows in your family and some of you divorced crows.

Every crow you know has the same mentality. They all want you to stay in the field. Your freedom signals their demise. If you are liberated, they lose their meal ticket. As long as you are on the pole unable to dream, stuck in your position of powerlessness, you give power to the crows in your life because crows want you to go against your purpose and ignore your anointing.

In the film there are crow commandments! The crows make Michael Jackson recite the crow commandments. (And the crow commandments mess me up.) The number one crow commandment is "Thou shall honor all crows." In other words, you have to believe the crows are superior to you. As long as you believe the crows are superior to you, then you will stay in your position in the field. You are never to believe you are on the same level as the crows because the crows say, "Thou shall honor all crows."

In addition to that, the other thing that messes me up is the repetitive scenario in the film in which Michael Jackson is always attempting to read something. He pulls some stuffing out of his own body and begins to read. He will read and then the crows will respond in unison, "Come on. You've got to recite the crow commandments. Thou shall honor all crows and thou shall not read."

Hmmm. . . . That's fascinating. Here are some crows telling a young man who has some potential but doesn't know it that he should not bother reading because reading will liberate him! Reading will expand his mind. Reading will open up new horizons. Sadly, there are crows around our children telling them they do not need to read because if they start reading they might get out of the field. If you start

reading, you will come down from that pole. If you start reading, you will realize that you are created in the image of God.

We cannot have that kind of empowerment in our community because while you are up there on the pole you might recognize what we, the crows, have known all along—that there is power in you. After the crows tell you, "Honor all crows," then they tell you, "Don't read." Next they state the third commandment that you must remember: "Thou shall never come down."

In other words, stay in your position. Do not ever think outside the box. If you ever think that you can run the country, we will get a whole bunch of tea party crows to remind you that you weren't supposed to come out of the field in the first place. "Thou shall never come down." The scarecrow believed he was stupid. He believed the stereotype that the crows had created for him. This belief system isn't anything that Scarecrow created. The crows designed it for him and miseducated him, and now he's operating with a crow mentality—a crow mentality.

Part of the challenge is we have believed everything the crows told us. Yes, I recognize that we are in a state of emergency. Yes, I recognize that the dropout rate is 50 percent for black boys. Yes, I recognize that we are filling up the jails. However, this is not in our DNA. This is not who we are. Thank God there are some brothers who did not listen to the crows in their life, and if you are one of the brothers who made it out of the field, if you are one of the sisters who made it out of the field, if you came down from the pole, stepped out of that place, then it is your duty to make sure somebody else comes out of the field.

You have to stop listening to the crows. If you are stuck up there on a pole with a crow mentality, you need to come down. Do not listen to all of the crows in the media. You need to know that you have the fingers of a Herbie Hancock and the breath control of a Wynton Marsalis. You have the intellect of a Cornel West, the hermeneutical

prowess of a Jeremiah Wright. You have the poetic touch of a Saul Williams, the business mind of a Tom Burrell, the educational acumen of a Robert Franklin.

Do not listen to the crows, because if you listen to the crows you will always stay stuck on the pole. For one reason or another you can decide to confound the world. The world, from the moment we landed in America, set it up so that we would stay in the field. Can you imagine that? An entire government was against a group of people, but look at what God has done. The resources of the wealthiest country on the planet were designed to keep you in one particular place, but look: You have transformed the country! Now one who was told that he could never enter the house through the front door is running the thing.

Crows don't have any authority. You have to understand this and stop thinking small. Stop thinking like crows. As for Paul, when he writes in Romans12:2, "Do not be conformed to the culture of this world but be transformed by the renewing of your mind," he was talking to people who were listening to Roman crows.

The Roman crows were saying, "Stop following this man, Jesus. You need to follow Julius Caesar. Caesar is the son of God." But Paul is saying that you need to renew your mind. Because if you get your mind straight, in the words of George Clinton, everything else will follow. If you get your mind straight, then all of a sudden you will see the world in a completely different way. God is calling God's people to renew their minds and not be miseducated by crows.

How do you tell who the crows are? You have to be careful. Remember this: You can always tell crows; however, you cannot just look at the exterior and detect a crow because there are some crows that look good to you, some crows that look strange to you, some crows that are riding nice and there are some crows that are rolling in their hoopties. It does not matter what is on the outside. You can tell a crow by two things. You can tell a crow by what the crow says and by the other birds the crow hangs out with. Crows roll with crows. Crows do not hang with eagles, and they never sing with spar-

rows. Crows hang out with other crows, and they like other crows around them so they can talk crow business. And I am sorry to let you know there are even crows in the church. I have to be honest. I cannot stand being around crow folk, because all they want to talk about is something negative.

The God we serve has done great things. Even when I wake up in the morning and it is raining outside and cold, I am still thankful. I cannot have crow thinking in my spirit. And I am here to let you know that you need to tell the crows next to you to go on and shoo! Shoo the crows away. It is easy to get rid of crows. All you have to do is say, "Get on out of here!" See, crows will not hang around when you start talking good things. Crows will not hang around when you talk about the goodness of the Lord.

So we see that this scarecrow has been miseducated. Crows always hang out in flocks. And the reason they mess with Scarecrow and want Scarecrow to be miseducated is because he is a threat. The real reason the crow party is after you or after us is because we represent a threat.

If you have no crows in your life, if you cannot find any crows around you, if you look to your left and to your right and there are no feathers next to you, then you just might be one of the crows! Crows have a problem with Scarecrow because he is a threat. And when you watch the film, you will see that they are trying to get him to stay miseducated. Ah, but Scarecrow wants to renew his mind.

But consider this about the film and also about this text: Even though the crows want Scarecrow to stay in his position, they do not realize that putting him in his position always elevates him. Even though the crows are keeping Scarecrow in the position on the pole, he still is elevated above the crows. Because of his elevation, they have to look up to him.

There is somebody else I know who was elevated when some crows thought they were actually destroying him. However, he was able to draw all men unto God. You have to be careful whom you try to destroy, because in the process you may end up blessing them. Jesus

had crows—Pharisee crows, Sadducee crows. Peter acted like a crow. Judas was a crow. Crows can be in your inner circle.

You can be possessed by a crow mentality. Even Peter, the one upon whom the church would be built, acted crow-like from time to time. The question before us is, how do we get out of the field? If we've been miseducated, how do we get out of the field, brothers? How do we get out of the field, sisters?

Well, there is a simple thing that happened in the film, that happens when your mind is renewed and you realize that you do not have to stay in the field. Watch what happens. Although the crows were controlling the Scarecrow, he was elevated. But if he had been down on the field when Dorothy came along, she would have missed him on her way to the Emerald City. Because he was elevated, Dorothy was able to see him, and because she was able to see him, she was able to shoo the crows away from him.

As Dorothy, played by Diana Ross, is shooing the crows away, she says, "You need to come on down," but Scarecrow Michael Jackson says, "You know I can't walk." She says, "Come on down. You are just a victim of negative thinking."

Dorothy brings him down. Dorothy helps him out. The reason he is able to come down and move to his purpose is because somebody intervened in his life. Stop trying to act like you came down all by yourself. Like you did it yourself and did not have any help. There was somebody who saw what you were going through, stepped into your situation, liberated you from the crows, and now you are easing on down the yellow brick road on your way to being liberated.

Scarecrow needed somebody to believe in him, to say that all you have to do is put your best foot forward and ease on down this road. And everybody here, all of us are beneficiaries of somebody who intervened in our field and said we didn't belong there. Stop trying to act like you have been in church forever and you have been perfect all your life. There was somebody praying for you. There was somebody lifting you up to let you know that you didn't belong

where you were, where you may be currently. I am here to get you out of your field.

Scarecrow had to learn how to walk on his own. His mind was renewed as a result of his connection to Dorothy. When you are connected to the right people, they can put you on the right path. When you are connected to the right folk, they will put you on a path where you will be able to receive what God is calling you to do. When the right people put you on the right path, you can ease on down the road and find out that you actually have some power in you.

Now, what I like about the movie is that Michael Jackson says, "I don't have a brain," and yet, he did have a word in him he kept pulling out and he kept reading: "Blessed are the pure in heart, for they will see God." He kept pulling a word out: "No weapon formed against me shall prosper." He kept pulling a word out and found out that "the Lord is my light and my salvation." He kept pulling a word out and found out that "the Lord is my shepherd; I shall not want."

He kept pulling a word out: "They that wait upon the Lord shall renew their strength." I'm here to let you know that if you have a word in you when you get in trouble, you can pull it out, pull it out, pull it out, pull the word that's already in you out. God has put a word in you.

God will put a word in you, and when you pull the word out that God has put in you, you find out you can walk by yourself. It was the scarecrow who found the yellow brick road and found out that if you ease on down, ease on down the road, don't you carry nothing that might be a load. Just ease on down the road. You need to put your right foot in front of you and "trust in the Lord with all thy heart and lean not unto thine own understanding. And he will make thy paths straight."

God put something in you so that you no longer will be miseducated, so that you have power in you. You have strength in you. You have God's strength, so keep on. God does not want you miseducated.

Somebody—we do not know who—filled the scarecrow with the word. That somebody was gone—we don't know who it was—but in the time of trouble, the scarecrow could reach in and pull some stuff out. It is the same with you. I do not know if it was your grandma; I do not know if it was your mama; I do not know if it was your daddy. They may not be here with you, but they put something in you!

Stop acting like you can't walk for yourself. Stop acting like you can't deal with those crows. God put something in you already. All you have to do is reach down and pull it out. Reach down and pull it out. This is what God is calling us to understand. Don't let crows define you, tell you who you are. You are a child of God. Stop saying "I don't have anything in my head."

You have enough in you to sustain yourself, and when you realize you have something in you, you will notice that the crows will disappear. No longer will they hang out with you. Crows want to hang out in the field with you, but as soon as you get a new address, you will move to another altitude to which crows cannot fly. God wants you to understand that there is something already in you.

QUESTIONS FOR REFLECTION

1. "Miseducation" is the attempt to undermine a person's self-esteem, identity, and worth. In what areas of your life have you been miseducated? How did you overcome the miseducation?

2. There are all kinds of "crows" in the world. Their mission is to control and inject negativity into people's lives. Who or what are the crows in your life? How do they affect you? How can you defeat them?

3. What are the elements of "crow mentality?" How do these elements show up in your life? What can you do to counteract "crow mentality"?

4. The Apostle Paul urges the Christians in Rome to be "transformed by the renewing of [their] minds." What does this mean? What process of renewal do you practice? How can the church support this transformation in people's lives?

5. Scarecrow was always searching for knowledge and truth. Why do you think he was on this quest? What advice or wisdom do you offer him for his journey?

THREE

THE GOSPEL ACCORDING TO *THE WIZ*

The God in You

❀

SCRIPTURE: 1 JOHN 4:4

I f you have your blueprints for salvation, the guide upon our journey, the rudder of your ship, I kindly ask that you turn to First John, chapter 4, verse 4. We read from three different translations.

The New International Version reads this way: "You, dear children, are from God and have overcome them, because the one who is in you is greater than the one who is in the world."

The Message translation reads: "My dear children, you come from God and belong to God. You have already won a big victory over those false teachers, for the Spirit in you is far stronger than anything in the world."

The King James Version, with which you're familiar, reads this way: "Ye are of God, little children, and have overcome them; because greater is he that is in you than he that is in the world."

Beloved, the text in First John is a congregational letter or, as some scholars would say, it is a parish sermon, designed to communicate and educate the listener to the nature of God and the mechanics of spiritual development. The first three chapters spend time slowly and

methodically telling the church about the proper connection and how love operates within the economy of God.

When you read First John, Second John, Third John—and it will not take you long to read; you can read all three letters immediately after the service—you will find in First John that the writer spends a lot of time talking about a particular dichotomy—that it is not possible to love God and to despise your brother. The writer goes on to say that someone who claims to love God and despises his or her brother or sister is a liar. Because it is not possible to shout on Sunday and then be ready to cuss someone out on Monday.

The writer is saying that one must understand that the love of God is not exclusive—if you want to love God, whom you have not seen, and then despise your brother, whom you see every day, then you cannot be operating within the will of God. You will block your spiritual circulatory system and you will not be able to receive the proper nourishment when you choose to have only a vertical relationship with God and miss out on the horizontal relationship. Because anyone who just has a vertical relationship with God without a horizontal relationship with God and God's people does not have a cross, all that person has is a stick.

God wants us to have the kind of relationship that not only can praise, not only can shout, but also can offer love to those whom we see every day. When confronted with love and affirmed by love, something happens to the human spirit. Every child, every parent understands that children naturally gravitate to nurturing, caring people and that they respond to love in unique ways. Love will make you a better person. Love affects our bodies. When you are in a loving, caring environment, your body's immune system operates better. You can fight off disease better when you are around people who love you.

Doctors have concluded that a loving environment will improve your memory. Not only will you be able to remember things, some of you will be able to delete some things as well. One study even found that those who are in a loving and affirming environment had muscles

that were 5 percent stronger. There is increased strength when you are around loving and caring people, and when you are around loving and caring people you sleep better. You do not have to sleep with one eye open, and you show fewer signs of stress. Love has the power to actually alter our physiology.

First John spends time trying to explain to the church the dichotomies of serving and loving God and God's people. As we continue to read, we notice that the writer's passionate argument is rooted in the fact that, as one commentary points out, it is a group of people that this writer is writing to, a church; it is a congregational letter. However, there is a group in this church that made the decision to leave the church. The call of Roman society was too great and when they looked at all that the church had and all that the Emerald City of Rome had, they made the decision that Rome must have the hand of God upon it.

Because the church was oppressed, the physical landscape of the church was on the margins of society. Rome—which did not follow Christ—seemed on the outside to have everything. And the evidence that this group within the church utilized was based upon what they could see; they looked at the temples in Rome and saw the grand architecture. They looked at the armies that seemed to never lose a battle; they looked at the clothes that those in the Senate wore and the land that those who had affiliations with the temples had, such as the temple of Athena. Yes, it seemed as if those belonging to the Emerald Empire of Rome had everything.

God must be with them because they have big homes, they have large temples, they have nice houses and plenty of land. God must be with them because when one looked with the external eye, it seemed as if God's hand was upon them. Now this writer of First John is saying, "No, no, no, you are looking at the wrong thing"; he is saying that you must understand that "greater is he that is within you than the one that is in the world." The external does not determine God's favor. In the words of my grandmother, "Everything that glitters ain't gold."

The writer tries to express the fallacy of looking at things from the outside by saying, "Greater is he that is within me than he that is within the world." And when you see what you are looking at, you may think that validates that God's hand is upon it, but in reality it is not the external, but rather the internal that determines the kind of authority and power one has. When we connect with this Emerald City of Rome and look into the Land of Oz, we see some connections between the life of Dorothy and what the believers in First John were dealing with.

If you'll remember, in the film *The Wiz*, Dorothy, who is from Harlem, lands in Oz as a result of a storm. And when she comes to Oz, she wants to get out of Oz, of course, so everybody tells her if you want to get out of Oz, follow the yellow brick road, make your way to the Emerald City and find the Wiz. She is told by everybody—even though nobody has met this man, the Wiz—but she's been told by everybody that this man has power. In the end, however, we find out along Dorothy's journey that this wizard has no authority and no power. She spends most of her journey trying to hook up with a man who has no authority and no power. Dorothy has been told by everybody that this man has power, but when she finally hooks up with the man, she finds out that the man has a little something on the outside, but nothing on the inside.

Dorothy spent her entire time trying to find a wizard who had no power. Now, the one in Oz who actually has power is Glinda. Glinda has been there all the time, but Dorothy decides to go after somebody who doesn't have any authority and power. After she realizes that the wizard has no power, then Dorothy connects with Glinda, who does have power. The point I am making is that we, as a community, many times chase after wizards who have no power, who have no authority, and then as a last resort, we go after God. How many times have you heard "Now that you've tried the rest, try the best," which is Jesus?

My particular question is, if Jesus is the best, why is he a last resort when he should be the first option? When you are in your Oz, you

need to make sure you can connect with somebody who has power. Instead, we spend so much time chasing after people who have no power because we think they will wave a wand and change our lives. If you don't first understand what is in you before you try to connect with somebody else, that other person will make a mess of your life. We put too much power in the hands of other people (there is no wizard who will deliver you).

There is no man who will show up at your door and knock, and all of a sudden everything will be all right. There is no politician you can elect who will change your life forever; there is no organization you can join that will change your life. No, you have to understand that God put something in you, that God's fingerprint is upon you, that "greater is he that is within you than he that is within the world." We love to place wizards on pedestals; however, there is no wizard, there is no politician, there is no pastor or preacher who should be placed upon some pedestal as if that person can deliver you. The only person I know who has the power of deliverance is not a politician, is not a pastor of some megachurch, and is not the one who runs any particular civil rights organization.

The only one who has authority to deliver is a man by the name of Jesus. And when I think about him and all he's done for me, my soul cries out, "Hallelujah!" Jesus is the only one! So often in our community we get caught up in what is called "charismatic leadership," that is, as soon as someone dies or no longer leads an organization we think that all is lost, but God is still on the throne. God is not God based on who got elected; God is not God based upon who runs such and such organization; God is God whether you are in the driver's seat or not. God is God whether So-and-So still runs an organization or not, and we must understand that many times we waste too much time chasing wizards.

The wizard in *The Wiz* is amazing to me. Played by Richard Pryor, this wizard in his real life "couldn't even get elected dogcatcher." He did not have any authority or any power, yet everybody was send-

ing Dorothy to him when there was already a way for her to go home. There were so many challenges that Dorothy and her friends encountered on their way to the Emerald City, and when they finally made it to the Emerald City, they almost ended up staying there because of their trust in the wizard.

They began to enjoy Oz. Once they made their way to the Emerald City, they saw the expansive buildings and how everybody in the Emerald City was focused on their clothes and how they walked. The color was red or the color was gold or the color was whatever the Wiz decided that the color would be. They were focused on the things that were important to the people of Oz. One thing that you must understand is that, if you are to leave Oz, you must make a decision that you're not going to stay in Oz.

Don't ever get so comfortable in your Oz moment that you think you're willing to settle for Oz. Oz is not your home, Oz is not where you live, Oz is not your destiny, and if you spend enough time around people who love Oz, you will begin to think Oz is normative. You need friends who do not want to be in Oz. Now, Dorothy and friends were waiting on this particular wizard to deliver them, but they had to make a decision, and when you make the decision, it's got to be the one you can live with. Prior to Dorothy and friends making the decision to leave the Emerald City, there is a scene in the film where they are in the Oz hotel and they are thinking and talking about the possibility that staying in Oz may be all right, may be okay. "Dorothy, it's not as bad as you think; it could be worse."

The relationship could be worse; it's not as bad as you think; the situation is not as bad as it could be. We could stay here, Dorothy. Sometimes we end up settling for Oz because it's a slight upgrade from our last experience. But an Ozian is still an Ozian, even though now living in the Emerald City instead of living with the crows; that person still has the same Oz mentality. Ultimately it was Dorothy, Tin Man, Scarecrow, Lion, and Toto who said, "No, we can't be comfortable here; we have to leave." So how do they end up leaving? They make their way to see the wizard.

Once they make their way to see the wizard, they find out that he is a fake, as are all wizards. All wizards are fakes, and when Dorothy and her friends find out that the Wizard of Oz is a fake, they begin trying to figure out how to get home. Let me tell you something that was so powerful in the movie and that relates to the text: Glinda, the good witch, shows up. Glinda, played by Lena Horne, shows up. Glinda had been living in Oz all this time, and she reminds Dorothy that she can get home on her own. The power was already in her; while she were running around looking for the wizard, the power was already in her.

As a matter of fact, Scarecrow, you don't need the wizard to give you brains; you already have brains. Tin Man, you don't need the wizard to give you a heart; you already have a heart. Lion, you don't need anybody to give you courage; you already have courage. It's amazing to me that we can trust everybody else except God. We can trust in everything else more than we can trust in Jesus.

Some of you went to a restaurant last night; you ordered some food from a waiter you don't even know. That waiter went back into a kitchen you've never been to, and then a chef you don't know put some food in a pot you never looked at. That chef then put that food on a plate you didn't wash, brought that plate out to you, and you ate it and said, "Mmm, isn't this good?" You then pulled out your wallet and gave your credit card to the same waiter you don't know, who went back into a room you've never been in to start pushing some numbers, and brought you out a receipt and said, "Here, sign this."

When you are sick, you will go to a doctor, who will write a prescription that you can't even read, and you will take that prescription to a pharmacist that you don't know. And that pharmacist will go back into a room you've never been to, put some pills in a bottle, and say, "Here, take this two times a day."

Well, if you can trust a waiter you don't know, if you can trust a chef you don't know, if you can trust a doctor you don't know, if you can trust a pharmacist you don't know, you can trust in God. Because

"greater is he that is within you than he that is within the world." You need to put your trust in someone who can get you out of Oz. You need to realize that the power of God is in you. The very DNA of God is in you. When God created you, God left God's fingerprint upon you. In the words of our ancestors, "God don't make no junk." And here we are all the time talking about what we can't do; but don't you know the God we serve owns the cattle on a thousand hills, and owns thousands of cattle upon that hill?

Yet just like Tin Man we spend all this time talking about what we can't do and what we don't have: "If I only had a heart." Like the scarecrow: "If I only had brains." Like the Lion: "If I only had courage." You have everything you need because "greater is he that is within us than he that is within the world."

The power of God is in you, the power of God—yes, the power of God to order chaos and call something out of nothing and hang a celestial chandelier in the cosmos and call it stars—is the power in you. Do you know the power of God is in us? The same power that put heat in the flame and burning in the fire, and wetness in the water—that God's power is in you. The same God who put colors in the rainbow, roar in the thunder—that God's power is in you. The same God who put a flash in the lightning, drip in the raindrops, blue in the sky—that God's power is in you. The same God who put a peak in the mountains, depth in the valley, the God who expanded the plain—that God's power is in you. God put slither in the snake, buzz in the bee, crunch in the apple—that same God's power is in you. God's resurrection power, Holy Spirit power. This is the same God who could bring down the walls of Jericho, the same God who could part the Red Sea, the same God who gave Amos his passion—that God's power is in you.

Deborah's authority, Hannah's commitment, Samuel's discipline—that God's power is in you. The same God who could take a little boy's lunch and several biscuits and some catfish and feed five thousand—that God's power is in you. The same God who can res-

urrect after being in the grave is the same power and the same God that is in you.

Dorothy was told: If you want to get back, if you want to get home, if you want to see transformation, you've got to know that there's already power in you. If you want to win this transformation in our community, don't you wait on Superman; you need to know that we are supermen and superwomen.

You need to know that you've already got the power in you. The power is in us. Because "greater is he that is within me" and so when Glinda showed up, Glinda said to Dorothy, "Dorothy you don't need a wizard; the power is already in you." Dorothy said, "Whatcha talking about?" Glinda said, "If you want to go home, all you have to do is click your heels three times." Well, I don't know what clicking your heels three times means in Oz, but I do know something about the number three. I don't know what it means in Oz, but I know what number three means, that you can click your heels once for the Father, twice for the Son, three times for the Holy Ghost.

So when demons rise, you need to click your heels. When the devil shows up, click your heels. When people try to take you down, click your heels. Click three times and remind yourself of God the Father, God the Son, God the Holy Ghost; and just keep on clicking, keep on clicking, keep on clicking. God will deliver you. God will show up. There's power in you; there's authority in you. Can you click your heels knowing that God will deliver you? Can you click your heels knowing that the devil is a liar? Just click.

So the next time the devil rolls up on you, don't say anything, just click your heels. And when people ask what you are doing, just tell them I'm calling on God the Father, God the Son, and God the Holy Ghost because I know my God has the power to bring me out of Oz. Have you ever been in Oz, but you found that God would pull you out of your Oz experience? God will pull you out of your Oz. Glinda showed up. This is what Glinda did. Lena Horne came out in a nice outfit and said, "Dorothy you need to believe in yourself. You've been

listening to the wrong people; you need to believe in yourself." Greater is he within you than he that is within the world. So if you believe, you can get yourself out of Oz. In *The Wiz* Glinda shares with us, "If you believe within your heart, you'll know . . . there's a reason to be."* So believe in yourself, and believe that "greater is he that is within me than he that is within the world." God is waiting for you to make a decision right now, a life-altering decision. It's time.

QUESTIONS FOR REFLECTION

1. The Christian life is composed of a vertical relationship with God and a horizontal one with others. How do you nurture both the vertical and horizontal relationships? How can the church support your relationships?

2. The Wiz is a symbol of authority with the power to grant wishes and desires. Yet the wizard has no real power. What wizards have attracted your attention? How did you learn they had no power? How do you tap into God's power?

3. What has God placed in you that you need to share with the world? Don't be modest in sharing the gifts, skills, insights, and wisdom that God has revealed to you.

4. Glinda the Good states that we all have power within us. How do you engage that power? What hinders or keeps you from engaging the power within?

5. How does Dorothy discover the way home? What lessons does she offer us about faith and belief?

*"Believe in Yourself," words and music by Charlie Smalls 1974 © Warner-Tamerlane.

FOUR

THE GOSPEL ACCORDING TO THE WIZ

Running with the Right People

❀

SCRIPTURE: ECCLESIASTES 4:9–12; PROVERBS 3:5

Ecclesiastes 4:9–12 (NIV) reads as follows: "Two are better than one because they have a good return for their work. If one falls down his friend can help him up. But pity the man who falls and has no one to help him up! Also, if two lie down together, they will keep warm, but how can one keep warm alone? Though one may be overpowered, two can defend themselves. A cord of three strands is not quickly broken." The New Revised Standard Version says, "a threefold cord is not quickly broken." Moving to Proverbs, chapter 3 (NIV): "Trust in the LORD with all your heart and lean not on your own understanding; in all your ways acknowledge him, and he will make your paths straight." Two are better than one. Two are better than one. A threefold cord is not quickly broken.

Beloved, the book of Ecclesiastes is a peculiar book within the Hebrew canon. Scholar Rev. Howard Thurman argues whether the composition is structured as poetry to be engaged with a metaphorical and lyrical ear, or prose designed to be engaged with rhetorical criticism.

Regardless of whether one falls into the metaphorical or rhetorical camp, this book is a skeptical dialogue on the human condition with nihilistic overtones in which the writer shares with the reader the dilemma of being human. Our state of living is absurd and the energy we put into faith and to obtaining status and wealth, privilege, and recognition, according to the writer of Ecclesiastes, is nothing but vanity. Only God is the source of our true identity. We are to fear God and to seek to live our lives based upon God's command. This book lays out the vanity of pursuing self-righteous, indulgent activities, and to further his case, the writer states that in the totality of our human endeavor, we eventually go through the entire landscape of joy and pain. Therefore, you must be careful about pursuing things that really have no lasting value.

In the third chapter he goes on to lay out the argument, saying there is a time to be born and a time to die. There is a time to plant and a time to pluck up. There is a time to kill and there is a time to heal. There is a time to tear down and there is a time to build up. There is a time to weep and there is a time to laugh. There is a time to mourn and there is a time to dance. There is a time for everything under the sun. In the human experience, all trajectories are possible, and we all pass through the different seasons of life. If one is to manage the currents of existence, one must understand that two are better than one.

We must understand that one should live life in community, live life in a village. Life's journey should be experienced in community and not in isolation. Alone, we do not have all the resources nor the complete color palate to paint upon the canvas of life. Our toolbox is inadequate. Our library is understocked and our hard drives have limited capacity; two are better than one. A life should be experienced as a symphony and not as a solo. There will be solo moments, but the power and richness of the choir deepens our understanding. If one really wants to understand not only this particular book, but how it engages with this film that we have looked at, know that there are only a few plot points or stories in the world.

There are a range of tales, but one writer says there are really only seven basic stories, and we just keep recycling those stories over and over again. There are stories that deal with self-discovery, stories of human versus nature, stories of human versus human, stories of redemption, stories of revenge, love stories, and journey or quest stories; and most literature or films are varieties of these basic stories. Toni Morrison, for instance, always combines self-discovery with humanity struggling against humanity.

Within the backdrop of racism, of informing about certain issues and telling the story, *The Matrix*, *Star Wars*, *The Book of Eli*, *Avatar*, and *The Wiz* are all journey stories or quest stories where the protagonist's journey is captured in the process of him or her becoming a better person by way of reaching his or her destiny. We come to our final message in our series "The Gospel according to *The Wiz*." In this particular movie, we find an understanding of this scripture that two is better than one. As you remember in the movie *The Wiz*, the story is of a woman from Harlem by the name of Dorothy, who has a little dog named Toto, and a storm comes along that lands them in Oz, a place that they were not supposed to be in the first place. It is not home. They have to journey to Oz and there they are told that it is not possible for Dorothy and Toto to get out of Oz on their own.

They must take a journey, and on the journey they will meet other people who will help them to get back home. As they journey in Oz, they first come upon a gentleman—the scarecrow, played by Michael Jackson (previous to *Off the Wall* and *Thriller*). There he is in the field, and the only reason he is in the field is because the crows have told him he is stupid.

The only reason he stays there is because he has crows, whom he thinks are his friends, telling him that he's to stay in his position and be a field scarecrow. They tell him that he should not leave the field, because if he leaves the field, they lose part of their meal ticket. The crows are exploiting the scarecrow and they get the scarecrow to actu-

ally believe that they are his friends. Even though he is an intelligent scarecrow, he believes whatever people are saying about him.

The people Scarecrow has been hanging with keep lowering his destiny, and so it is not until Dorothy and Toto show up that he is able to be released from his particular pole and find his way down the yellow brick road. If Dorothy and Toto had never shown up, the scarecrow would still be in the field. They were not invited to intervene; instead they saw that he needed some help, so they intervened even though he did not request help. They intervened in his situation even though he did not pray for intervention or ask for intervention. Somebody intervened anyhow.

Even though the scarecrow did not want anybody to intervene, did not know he needed intervention, somebody intervened anyhow. This is how God works in our lives. Many times we do not ask for intervention, but God will intervene anyhow. Once you realize that God has intervened, you see that there is broader world than the world that you have been experiencing. I'm glad that we share a God who will enter into your life without your permission, a God who will show up in your situation without you inviting God to come into your life.

You know you are happy, excited, and glad that we serve a God who knows when to show up even though you don't know how to invite God to come into your situation. Many of us would still be in the field, still be in Oz, still lying out in the cold, if somebody had not intervened in our situation and told us that we don't have to stay on that pole—that we can move out of the field and become the person God wants us to become. Dorothy and Toto intervened on behalf of scarecrow.

Two are better than one because they are now operating as a community and as a village, and Scarecrow has been liberated from his cornfield—and yet they are still living in Oz. Dorothy's trying to get out of Oz, but now there's somebody who's running with her and she has the right person running with her because the scarecrow is an intelligent brother even though he doesn't believe he was intelligent, as we said before.

He already had a word in him, and every time he pulled out a word, he was inspiring people to move in the right direction. So it is scarecrow who finds the yellow brick road, and they ease on down that yellow brick road. They come upon an abandoned amusement park, where they hear the sounds "help, help, help me," and they begin trying to figure out where the sounds are coming from in this abandoned amusement park.

Eventually they push over a large metal character, and under this large metal character is a tin man. Tin Man has been stuck underneath this large metal character. He was left behind in the abandoned amusement park because, in the words of the tin man, he was always chasing after the wrong type of people. He says to Dorothy and the scarecrow, "Oil. I need a little oil. I need some oil in my life. Can you provide the oil?" Somebody has to bring the oil to him so that he can be unstuck from his situation. He's delivered by Dorothy, Toto, and the scarecrow, but you must understand how he got into the position he was in in the first place.

You remember that Tin Man, played by Nipsey Russell, got into his position because he was in love with a big character in the amusement park, and every time he thought about her he would start crying over his past relationship. As he cried over the past relationship, he rusted out, and because he rusted out, he got stuck in his present, crying about the past. He was crying about yesterday, got stuck, and couldn't move to his future.

Somebody had to bring some oil to his life in order to liberate him so he could move to where he needed to be. Closed doors got you stuck in the past, unable to move into your future, and left you needing oil and without the fuel to get out of the situation. You need oil to change your life. The tin man knows what he needs. He can only operate so long without oil.

When you have love in your own heart, you feel like you can make it. "I got some oil, babe." Those who wait upon the Lord can renew their strength, they shall mount up with wings as eagles. They shall

run. You may feel a little rusty, but the word of God is enough oil to get you moving, get you standing. Have you ever felt stuck, but once you came to church, you got some oil to free you?

Tin Man ends up disenfranchising himself by crying over yesterday, and his tears end up imprisoning him, . . . but the same tears end up resurrecting somebody else. Remember when Dorothy and the lion went into the poppy field and they ended up going to sleep? The one who resurrected them was the tin man, whose tears came down on them and woke them up. I know somebody else who, before he resurrected Lazarus, had to cry some tears, and after the tears flowed, then Lazarus could get up.

Some of your tears may keep you in your past, but somebody else's tears may push you to your future. If your momma hadn't cried over you, if your daddy hadn't cried over you, if your friends hadn't cried over you, you wouldn't be where you are. Thank God for somebody's tears. Two are better than one. So this journey story, which is essentially about this woman Dorothy, who was running with the right people, is about her coming to understand that she can't get out of Oz by herself. There's another character in here, that most people don't like to talk about, but he's my man.

This character is a little guy, the smallest guy in Oz, but he's the man. His name is Toto. Toto's no chump. I like Toto. The reason I like Toto is because, as you remember in the story, now Tin Man has been liberated, Scarecrow has been liberated, and Dorothy, Tin Man, and Scarecrow are on their way to the Emerald City to see Oz (two are better than one). They recognize they must do this thing together, and they are walking along their way, skipping, they are so excited going down the yellow brick road. They walk past a library, and they look up and see some stone lions, and one of the stone lions seems to be looking at them.

Every time they look at the lion, the lion's looking back at them. They are looking at the lion, the lion's looking back at them, and all of a sudden a real lion jumps out from behind the stone lion, leaps out

and scares the scarecrow and the tin man. The lion frightens Dorothy as well. She falls out, but one person says, "Uh-uh, I ain't rolling like that." Little Toto says, "Uh-uh, you ain't gonna mess with me," and he runs after the lion and bites his tail. The lion starts crying he's a lion and Toto is just a little dog. However, Toto says, "You threatened my family and I do not care how big you are, I am going to stand up to you. You may take me out in the process, but there are going to be a few bites and scratches in this fight, because it is not the size of the dog in the fight, it is the fight in the dog that is in the fight. My name is Toto, and you are not going to mess with my family."

We need to have a Toto mentality, that when we see what seem to be insurmountable odds, we need to take the perspective that you are not going to mess with my family, my people, just as Elijah did at Mount Carmel and David did to Goliath. We need to have the same mentality when the lions come for our children. Even though you may not have the same kind of strength and power as a lion, you need to have a Toto mentality.

I am going to do whatever I need to do to ensure the development of my children, of my community, because it is the fight in the dog, not the size of the dog, that matters in this fight. You don't have to be the biggest one. You don't have to have all of the resources. Just ask someone by the name of Stephen Biko. Now, Stephen Biko was a part of the black consciousness movement in South Africa. He was interviewed at the height of the anti-apartheid movement and was asked, "Do you think you can win this fight?" At that time, South Africa was a terrorist state supported by the United States, France, and Israel. Biko responded to the question by saying, "It has nothing to do with size. It has everything to do with our heart."

We understand what we have been called to do, though it may seem insurmountable, but we have something that our oppressors do not have. We have a deep faith in God. We have a deep faith in what our ancestors have already done. As we survey the landscape and see all of the challenges before us, it may seem insurmountable, but if you

have a little Toto in you, you can stand up to the lions of racism. If you have a little Toto in you, you can stand up to the poverty. If you have a little Toto in you, despite the miseducation that goes on in our school system, if there is a little Toto in you, you know you come from a lineage of people who are able to stand toe to toe with the powers that be. If our ancestors could do it, why don't you think we can do it? There needs to be a little Toto in you to remind you that you can stand up to those who may be more powerful. We have a God, we are connected to God, and we possess a deep faith in what God can do. So it is with Tin Man and Toto, and now the lion is running with them.

This is what I like about the lion. He said, "I don't have any courage," and they said, "Well, come along with us down the yellow brick road. We're trying to make our way to the wizard, and the wizard might be able to provide you with courage." Something happens on the journey. Remember, the lion started out as a coward, but when they move into the subway and they start getting attacked by all these inanimate objects, it is the lion who fights everybody's battle. He started out as a coward, but he grew into a warrior. In other words, he grew into who he was supposed to be. He didn't start out the way he was supposed to be, but he developed into who he was supposed to be. That is what I love about God.

You do not have to start out a certain way. God can see you in the future; God sees what you are supposed to be, and that is what I love about the church. You are not the same person you were last year and you will not be the same person next year. Every rung goes higher and higher, and God continues to move in our lives. And I am so glad that God doesn't demand that we be at our highest potential when we start our walk with God.

Jesus did not start out the way he ended up. He started out as a little baby that his parents wanted to take care of. He had to grow, it says in the scripture, in wisdom and in stature. He had to develop; he had to grow. That is my challenge with so many church folk. These church folk (I didn't say Christians, I said church folk). These

church folk don't believe in growth. They want you to be at a particular level all the time and if you were to Tivo their lives and go back into their pasts, you would learn that they haven't always been what they were supposed to be and what they claim to be right now. However, they want everybody else to be all perfect, and this, that, and the other.

Keep your mouth shut because, truth be told, you weren't doing what you re supposed to be doing. It is only by the grace of God that you have been able to grow into the person you are right now, so stop rolling your eyes at our young people. Stop rolling your eyes at all of these people coming into the church. You used to be one of them at one time. You used to roll your neck and act a fool every once in a while. You need to let them know that you aren't perfect either, and encourage them. Growth is what the lion demonstrates to us.

Two are better than one. This is the community that is developing, and so now we have Dorothy, my man Toto, Scarecrow, Tin Man, and Lion. However, the story is really about Dorothy, Dorothy getting out of Oz, but look—as I began to really look, it just jumped out at me, what was happening on a metaphorical level with the story. Ah, and when I look at this scripture . . . look who's rolling and running with Dorothy: Toto, who will never leave her; Tin Man, who cares for her; Scarecrow, whose thoughts are not like her thoughts; and Lion, who will fight her battles. Let me repeat that. Look who's rolling with her: Toto, who will never leave her; Tin Man, who cares for her; Scarecrow, whose thoughts are not like her thoughts; and Lion, who will fight her battles.

Dorothy has Toto, who will never leave her. Dorothy has Tin Man, who cares for her. Dorothy has Scarecrow, whose thoughts are not like her thoughts. And she has the lion, who will fight her battles. Well, you don't need Toto and you don't need the tin man. You don't need the lion and you don't need a scarecrow. I know somebody else who's three in one, who will fight your battles, whose thoughts are not like your thoughts, who will never leave you, and who cares for you. That's

the Father, the Son, and the Holy Ghost, and if you walk with God, God will take you out of your Oz.

Dorothy is trying to get out of Oz. But there is one more thing I need to tell you. If Dorothy never went through Oz, she would never become the strong, developed person she is at the end of the film. In the film there is always somebody watching over Dorothy, but Dorothy does not know it. There is Glinda, the good witch, watching over Dorothy. The entire time, she has been watching over Dorothy. Dorothy thought she was alone in Oz, but Oz was designed to develop her.

She had to go through her Oz experience so that she could be a stronger person, but she found out that while she was in Oz that she had God's favor upon her. You must understand that God is not trying to destroy you by taking you to Oz. God is trying to develop you while you're going through your Oz, because if it had not been for your Oz, you would n0t know how to play. If it had not been for your Oz, you would not know how to work. If it hadn't been for Oz, you would not know how to kick some crows to the curb. If it hadn't been for Oz, you would not be as strong as you are today.

Can you thank God for your Oz because your Oz took you to another level in your development? Your Oz strengthened you and your Oz ended up blessing you, because now you know you have God's favor in your life. Two are better than one.

QUESTIONS FOR REFLECTION

1. The American ethos focuses on the individual; Christianity calls for connection and community. How do you overcome the "rugged individualism" espoused by our culture?

2. Dorothy's journey highlights the importance of companionship. What enhances connection and community for you? What are some barriers to connection and community?

3. Dorothy finds three companions on her journey: the scarecrow, who wants a brain; the tin man, who wants a heart; and the lion, who wants courage. What do you want God to grant you? Why do you want this?

4. What are the elements of a "Toto mentality?" Name the "Totos" in your life. How are you a "Toto" to someone you know?

5. With whom are you running? Will these people help you reach your destiny? Why or why not?

FIVE

THE GOSPEL ACCORDING TO
THE COLOR PURPLE

Living with a Fool

❁

SCRIPTURE 1 SAMUEL 25:1–40

Y ou have your blueprints for salvation, guide upon our journey, the rudder of our ship. We kindly ask that you open your Bible to 1 Samuel 25. I want to give you *The Message* translation by Eugene Peterson, translated and paraphrased from Hebrew into contemporary English. It reads as follows:

> Samuel died. The whole country came to his funeral. Everyone grieved over his death, and he was buried in his hometown of Ramah. Meanwhile, David moved again, this time to the wilderness of Maon.
>
> There was a certain man in Maon who carried on his business in the region of Carmel. He was very prosperous—three thousand sheep and a thousand goats, and it was sheep-shearing time in Carmel. The man's name was Nabal ([which means] Fool), a Calebite, and his wife's name was Abigail. The woman was intelligent and good-looking, the man brutish and mean.

David, out in the backcountry, heard that Nabal was shearing his sheep and sent ten of his young men off with these instructions: "Go to Carmel and approach Nabal. Greet him in my name. 'Peace! Life and peace to you. Peace to your household. Peace to everyone here! I heard that it's sheep-shearing time. Here's the point: When your shepherds were camped near us, we didn't take advantage of them. They didn't lose a thing all the time they were with us in Carmel. Ask your young men—they'll tell you. What I'm asking is that you be generous with my men—share the feast! Give whatever your heart tells you to your servants and to me, David, your son.'"

David's young men went and delivered his message word for word to Nabal. Nabal [which, again, means fool], tore into them, "Who is this David? Who is this son of Jesse? The country is full of runaway servants these days. Do you think I'm going to take good bread and wine and meat freshly butchered for my sheepshearers and give it to men I've never laid eyes on? Who knows where they're from?"

David's men got out of there, went back to David, and told him what he had said. David said, "Strap on your swords." They all strapped on their swords, David and his men, and set out, four hundred of them. Two hundred stayed behind to guard the camp.

Meanwhile, one of the young shepherds told Abigail, Nabal's wife, what had happened: "David sent messengers from the backcountry to salute our master, but he tore into them with insults. Yet these men treated us very well. They took nothing from us and didn't take advantage of us all the time we were in the fields. They formed a wall around us, protecting us day and night all the time we were out tending the sheep. Do something quickly because big trouble is ahead for our master and all of us. Nobody can talk to him. He's impossible—a real brute."

Abigail flew into action. She took two hundred loaves of bread, two skins of wine, five sheep dressed out and ready for cooking, . . .

We are moving down to verse 23:

As soon as Abigail saw David, she got off her donkey and fell on her knees at his feet, her face to the ground in homage, saying, "My master, let me take the blame! Let me speak to you. Listen to what I have to say. Don't dwell on what that brute Nabal did. He acts out the meaning of his name: Nabal, Fool. Foolishness oozes from him."

We are moving down a little bit further to verse 36:

When Abigail got home she found Nabal presiding over a huge banquet. He was in high spirits—and very, very drunk. So she didn't tell him anything of what she had done until morning. But in the morning, after Nabal had sobered up, she told him the whole story. Right then and there he had a heart attack and fell into a coma. About ten days later, God finished him off and he died.

When David heard that Nabal was dead, he said, "Blessed be God who has stood up for me against Nabal's insults, kept me from an evil act, and let Nabal's evil boomerang back on him."

Then David sent for Abigail to tell her that he wanted her for his wife. David's servants went to Abigail in Carmel with the message. "David sent us to bring you to marry him."

Beloved, I want to let you know that I found a journal. I found a journal, dust on the parchment. Old, ancient, yet still readable. The entries are those of a young girl and are similar to the entries made by the protagonist, Celie, in *The Color Purple*. Celie, as you will remember from the movie, the play, and the book, which, of course, came first,

was abused, raped, and sold into the hands of a man by the name of Mister, played in the film by Danny Glover.

The Color Purple was Celie's story of awakening. We witness a girl become an empowered woman. It's Alice Walker's book I draw your attention to, for when I found this journal in the corner of my imagination, it was written with the same urgency as Celie's journal/ prayers.

In Celie's entries, she would start every journal entry with "Dear God." It was a journal entry, but it was also a prayer; she was speaking to God about her life. In Celie's prayers, we witness a testimony many children tragically have endured. Children like Celie become adults who live in the shadow of the cruelty of a Mister. Though Mister may have left your life, and Mister may be dead in your situation, Mister still haunts your psyche and makes guest appearances. When life attempts to give you a premier of a happy moment but then the curtain falls and the lights dim, what was meant to be a glorious time or special moment becomes another snapshot in a long series of sweet memories that were turned to bitter realities due to the apparition of a person by the name of Mister.

The ghost of Mister still haunts many of us. Some know his anger. Some are familiar with his brutal touch, his cutting words. Others know what it's like to live in a family where you are just never good enough. The strange irony of Mister is his gender. His gender is obvious to us in the book and in the film. But cruelty is no respecter of gender, and the irony of oppression is that the Mister spirit is not exclusive to one gender; it can also live in a "Missus" body.

Wherever humanity seeks to snuff out the light of divinity bubbling up and burning bright in the spirit of a child, we encounter a Mister. Whenever humanity silences the song that is the inherent genius of an innocent child, it's a Mister or Missus encounter. Whenever bruises or a profane tongue try to tattoo the heart of a girl or boy, we encounter a Mister.

Mister is not just a mythic character or a figment of the powerful imagination of Alice Walker. Mister is real, shaped by patriarchal

forces, machismo mentalities, societal and social constructions, and power corrupted by anemic souls. People encounter a Mister or Missus every day.

The story of Celie is not just about her triumph over Mister. That's not only what it's about, but also about her journey of awakening and rebirth—the rebirth of a woman who will not be defined by her past. Celie's power is in her ability to go through hell and still be able to stay in contact with heaven.

There is a blues song that says if you're going through hell, don't stop. If you're catching hell, don't hold on. Just keep moving, and eventually you will find your way out.

As I mentioned, I found a journal. I found a journal similar to Celie's. This journal was that of a little girl, living in the ancient biblical time period of the Hebrew days, who became a woman in spite of the fool she was forced to marry. It was the journal of a woman, a young girl at the time, by the name of Abigail. I found this diary, and I simply want to read a portion of it for you this day. It reads this way:

> Dear God, Daddy said I had to go. I was the oldest, and they needed the money. Mister had been coming around asking Daddy for me. I was ten at the time the man started coming around. Daddy said I was too young, but Mister came around every year. By the time I started my woman's business every full moon, Daddy said I had to go. We were poor, and Mister had money. Mister gave Daddy four cows and three sheep for me. Daddy said, "Do what he tells you. We need these animals, and we need the money."
>
> I remember riding on the back of a donkey and watching the tent I had lived in. My old home grew smaller and smaller in the distance as I departed with this man I didn't even know. I saw my little sister and my little brother crying. My mama was silent and my daddy just turned his back. I was Mister's now. I was twelve at the time.

Dear God, he pushed me on the floor and told me to shut up. He smelled. He made noises, and then he stopped. He left the tent. I stared up at the hole in the tent and saw a bright little star. I guess I'm a grown woman now. If this is what it's like to be a woman, I want to go back and be a girl again.

Dear God, he says I must give him children. He says it's my fault he has no heir. He beats me, but I am not going to let him give me a child. Let a child live in the shadow of a man such as him? I refuse, Lord. Is that wrong?

Dear God, I see him for what he is now, a fool. He stays drunk all the time. I count the money, pay the debts, and he has plenty of sheep and goats, but he stays drunk. I've been putting money aside so when things go wrong and he goes on those spending sprees, we'll have enough money to pay our bills.

Dear God, how do you survive when you live with a fool? I never planned it. I never asked for this. I just ended up here forced to live this life, caught between a rock and a hard place. Tell me, what do I do? Lord, tell me what to do. If I leave, he says he'll kill me. If I stay, I think I'll die inside. What do I do? If I leave and he doesn't kill me, I will live the rest of my life with the shame of a woman who left her man, for I am nothing but property.

Dear God, I realized something today. I will not allow Mister to determine my destiny. I will now allow Mister to destroy me. Some young men came by the property today. They told me Mister refused to feed the men of a young prince named David (who is pretty good looking, too). I had to intervene because I know what these men will do. They were ready to kill everybody on the property. I went to speak to the prince. I put on my nicest outfit. I have to admit I really looked good. I told the prince—I fell down before him—I

told him that he needed to be upset with me because my husband is a fool.

While I was talking to the prince, I didn't realize what I did. I didn't realize what I said. I called Mister a fool publicly. Me, a woman, property, chattel—I named him for what he is. As soon as I named him, the fear left me. I realized what he is. He's just flesh and blood, just like me. I had listened to him most of my life; he would tell me what I was and that nobody would want me. I realize now that I had been listening to a fool. There was nothing wrong with me. As a matter of fact, I could have sworn that Prince David was flirting with me. Lord, I know I am married, but, man, that David is easy on the eyes.

I refuse to be defined by Mister. I am not ugly. I am not any of these things. I am a child of God. I am a creation of God. I am not a thing. I am not an object. As a matter of fact, my name is Abigail. I'm no longer going by "girl" and those other names he uses. Even though my parents got rid of me, my name is Abigail. My name means "rejoice." I'm going to rejoice from this day on, forever, for the rest of my life. I'm smart. I'm beautiful. I'm important. I'm a child of God. I will not be defined by Mister any more. I will not do it. I love me. If nobody else loves me, I love myself. I will not allow someone to define who I am.

I have all my life been worried about what a fool says about me. No, no, no, no. I am Abigail. I am a woman created to serve you. I deserve better than this fool.

Dear God, I told Mister how I saved his drunk behind from David's men. I told him how I had been putting money aside. I told him how I kept him from financial ruin. I told him that he is never to put his hands on me again. I told him everything. He tried to hit me after I told him all of that stuff,

but something welled up inside of me. As soon as he reached back to punch me, I stood up in the chair, and lifted three fingers, and looked him in the eye. It was if angels had stepped in at that moment and frozen Mister in place.

Then he tried to cuss me. He said, "You're poor. You're black, and you're ugly." I said back to him, "I may be poor. I may be black, but David doesn't think I'm ugly." Mister died right there on the spot. He could not handle the one he had considered property being a full human being. He could not handle that fact. He died.

I didn't realize this, but even though he did not do any estate planning, because he had no heirs, all of his property went to me. I became the wealthiest woman in Carmel. A fool hooked me up. Lord, have mercy. Have mercy. Have mercy. The man who tried to break me was now blessing me after he was dead.

Lord, after he died, some of David's men came by. They came riding some very nice horses, and they had a chariot. They said, "David just wanted to check in on you." He'd heard that Nabal died. He said that he remembers my kindness. Lord, have mercy. They said that if I climbed up in the chariot, I would be taken to David and that David doesn't want to treat me as property. He wants to name me as queen of all of Israel. I started out with a fool, and now I'm living with a king. I started out one way, but I ended up another way.

That is the journal entry of a woman by the name of Abigail.

She gives us two simple lessons; let me make those clear. She kept her faith even though she was living with a fool. Even though she was living with a fool, she never stopped communicating with God. Through her journal entries, just as Celie did with all of the mess and hell she was dealing with, Abigail never stopped writing to God, never stopped talking to God.

When you are in a foolish situation, do not stop talking to God. When you are going through hell, do not stop talking to God, because there is life after living with a fool.

QUESTIONS FOR REFLECTION

1. "Mister" represents anything that threatens to snuff out life and potential. What are some "Misters" in your life? How do you combat their negative effects? How can the church help people whose lives are being oppressed?

2. "Abigail" is a name composed of two Hebrew words: *Ab* (or *Abi*) means "father" and *Gil* means "to rejoice or be joyful." She is in a difficult situation yet her name is about joy. What is the history of your name? Does your name suit you? Explain.

3. Both Celie and Abigail are in difficult and abusive marriages. How do they establish and/or maintain their self-esteem under such trying situations? How can the church help persons who find themselves in hard situations and conditions?

4. How do you communicate with God? How does God communicate with you? Are there times when God seems absent or silent? Explain.

5. What advice do you offer to Celie? To Abigail?

SIX

THE GOSPEL ACCORDING TO
THE COLOR PURPLE

This Condition Will Not Be My Conclusion

❀

SCRIPTURE: LUKE 8:40–48

I f you have your blueprints for salvation, the guide upon our journey, I would kindly ask that you turn to the Gospel according to Luke, chapter 8. I want to read from *The Message*, interspersing a little bit of the King James Version. It reads as follows:

> On his return, Jesus was welcomed by a crowd. They were all there expecting him. A man came up, Jairus by name. He was president of the meeting place. He fell at Jesus' feet and begged him to come to his home because his twelve-year-old daughter, his only child, was dying. Jesus went with him, making his way through the pushing, jostling crowd.
>
> In the crowd that day there was a woman who for twelve years had been afflicted with hemorrhages. She had spent every penny she had on doctors, but not one had been able to help her. She slipped in from behind and touched the edge of

Jesus' robe. At that very moment, her hemorrhaging stopped. Jesus said, "Who touched me?"

When no one stepped forward, Peter said, "But Master, we've got crowds of people on our hands. Dozens have touched you."

Jesus insisted, "Someone touched me. I felt power discharging from me."

When the woman realized she couldn't remain hidden, she knelt trembling before him. In front of all the people, she blurted out her story—why she touched him and how at that same moment she was healed.

Jesus said, "Daughter, you took a risk trusting me, and now you're healed and whole. Live well, live blessed!"

Another translation of verse 43 says that in the crowd that day, there was a woman with an issue of blood. She spent everything she had on the doctors trying to deal with her situation, but those men couldn't do anything. She slipped in from behind and touched the hem, the fringe, a small portion of what was touching Jesus. At that very moment, her hemorrhaging stopped. Jesus said, "Who touched me?"

When no one stepped forward, Peter said, "But Master, we've got crowds of people on our hands. Dozens have touched you." Jesus insisted, "Someone touched me. I felt power going out from me." When the woman realized she couldn't remain anonymous, she knelt before him in front of all the people. She blurted out, told her story, why she touched him, and how at the same moment she was healed. Jesus said, "Daughter." He said, "Daughter, you took a risk trusting me, and now you're healed and whole. Live well. Live blessed."

The Color Purple, the brilliant book by Alice Walker, adapted for the screen and produced by Quincy Jones and Kathleen Kennedy and directed by Steven Spielberg, was most recently produced for Broadway by Oprah Winfrey. It is a powerful book. It is a powerful story. I

would encourage all of our teens and college students to pick up a copy of the book. If you have not read the book, read it and discuss it with someone. If you've not had the chance to see the film, go on over to Redbox or go and download it from Netflix.

The Color Purple as a film and a book has captured the imagination of many who have witnessed its power. I am, without a doubt, a movie buff. I can quote Akira Kurosawa, Martin Scorsese, Spike Lee, and Julie Dash. I love film, but The Color Purple has captured the imagination of my wife, my mother, and my grandmother.

I believe my wife, Monica, can quote every line in the film. She really knows the film well. My mother, and my grandmother when she was living, would speak fondly of one particular scene—the scene where Celie had a straight razor in her hand, and she was about to shave Mister. She simply says to Mister, "Put your head back." You know the line that I'm talking about. My mother and my grandmother would speak fondly of that scene and get tickled by that, and how Shug Avery got the vibe that Celie was about to do more to Mister than just shave him and how she took that blade out of Celie's hand just in the knick of time.

The Color Purple is one of the few Hollywood films to deal with gender inequality, race, racism, color, colorism, domestic abuse, redemption, and coming of age. The Color Purple is Celie's story, the story of a black girl who was violated by her father, sold to a man named Mister, and forced to live in the shadow of abuse. The power of The Color Purple, the power of the book, and the power of the film, is the ability to force us collectively and individually to face our issues.

Let me be honest here—if you think you do not have issues, please understand, we all have issues. Everyone has some issues. You have some issues in your family. It is not a question of whether you have issues or not, but will you admit that you carry a suitcase of issues stuffed with secrets and folded follies, pressed problems, and rolled-up regrets all locked away in your secret suitcase? The human condition is both resilient and fragile. One moment of trauma has the power

to create a cascading waterfall of pain destined to define one's development. We all have issues.

What I love about Jesus is that Jesus is kind of a detective. He has a detective-like proclivity to always find people who have issues and deal with their issues. Jesus will show up in the life of someone who has been marginalized and whom people want nothing to do with, and he will heal that person in such a profound way that it becomes a public statement of what God can do in someone's life.

You remember how Jesus showed up in the tombs and found a man who was half naked and cutting himself, and who had a legion of demons in him? Jesus asked him, "What is your name?" The demons had to jump out of the man, jump into a herd of pigs. They committed suicide, and the man was set free. You remember how Jesus stepped up to a man who was a paralytic. He was operating in church, didn't want anybody to know his issue, but Jesus ended up there. You also remember how Jesus stopped by at a well and there was a woman right there. He knew everything about her. Jesus has a proclivity, he is a detective, and he knows your issues. You can act like you don't have any issues, but Jesus already knows your issues.

What I like about Jesus is that he will pass by all the people who are neatly pressed and dressed and find the one person in the back who has his or her head down. Jesus will look at that individual and say, "I am bringing you out of the shadow so you can become the person God intends you to become." Jesus is always pressing his way to those who have issues and challenges. This book, the Gospel of Luke, is called the "liberation gospel." In chapter 8 Jesus defines family—and I want you to read all of chapter 8 in your own personal devotion time. Jesus states very clearly in chapter 8 that my family is not based upon my biology. My family is those who hear the word of God and know that the kingdom of God is near.

Jesus defines family, and then he masters the meteorological and atmospheric conditions by calming a storm. Then he releases demons from a particular man in the tombs. In the words of theologian Megan

McKinnon, this is all a setup. Chapter 8 is setting you up for this story. It is really designed narratively to set you up to understand that Jesus operates in a way that people in Rome never understood a person could operate in.

Here is Jesus on his way to minister when an ecclesiastical leader asks him to please come to his house. His twelve-year-old daughter is dying. Jesus said, "Yes, of course. I will respond to your request because I am God's son, and I respond to your request." So Jesus is on his way to deal with a twelve-year-old who has issues, because Jesus has a special place in his heart for children, as scripture illustrates: "It is better for you to put a millstone around your neck than to harm a child." Jesus has a real issue with those who want to harm children and has an issue with ministries that want to have nothing to do with children.

Here is Jesus. He is about to visit a twelve-year-old girl. He has an agenda. He already knows what he's going to do. He's going to stop this child from dying and help this ecclesiastical leader, but then there's a shift in the story that makes things so unique and exciting simultaneously because it really should not be here. There is an interruption in where Jesus is going. Jesus is headed to the ecclesiastical leader's house, but then there's a woman who cuts him off to keep him from getting to this young girl. Jesus has an agenda, but then a woman interrupts the agenda, and Jesus changes his agenda. I like that about God. God will shift God's agenda to deal with your particular issue. No matter what may be going on, God will stop what God is doing.

Here is Jesus on his way to deal with this twelve-year-old girl who is dying, and there enters a woman with an issue. A woman who is bleeding. A woman who has been bleeding for twelve years. He's going to visit a twelve-year-old girl, but there's a woman who has a twelve-year-old issue. He's on his way to see a young girl who's only been alive for twelve years, but there is a woman who has a twelve-year-old issue. Her issue has been around as long as this young girl has been living.

This woman has an issue of blood. She is hemorrhaging. She is an outcast because, based upon the patriarchal Levitical system, a

woman's monthly cycle was considered to be unclean, and as a result women had to be outside of the community for a total of eight days. On the eighth day, if they were to be integrated back into society, they had to have a man say it was okay. So a woman with had to live in a red tent for seven days.

Here is a woman who was not bleeding for seven days. No. This woman had an issue for twelve years. Wherever she sat, they said it was unclean. Whatever she ate, it was unclean. The clothes she wore, they were considered to be unclean. She kept bleeding everywhere. There were certain colors she could not wear. She was a woman with an issue of blood. Therefore, she was placed on the outskirts of society. You couldn't shake her hand. You couldn't touch her. You couldn't even drink water after her. She was an untouchable. You couldn't deal with her because she had an issue. She was a woman with an issue.

Some scholars suggest that since she was bleeding for twelve years, her issue began when she was a child. When she went through puberty, perhaps there was some type of violation, and she's still bleeding. She kept bleeding. Though she is an adult, she is still bleeding from the injury of her childhood. Though she is a grown woman, she is still bleeding the issues that befell her when she was a child. Wherever she goes, she leaves a mark of her issues. Wherever she goes, she is bleeding from her childhood.

How long have you been bleeding? You can't be yourself when you bleed. You don't have the strength. You don't have the power because you've been bleeding so long. There can come a time when you have bled so long that you think your bleeding is normal. People don't even realize that this isn't normal because they've never seen you without your issues because your issue is connected to your childhood. You're still dealing with your childhood issue. Every time you come in contact with somebody, you leave a stain on that other person from what you've been dealing with.

The church is full of well-dressed bleeding people. You have your clothes on. You have on the latest outfit, but there is still a whole lot

of blood. The challenge with bleeding people is that bleeding people prefer to be around other people who are bleeding. Many times when you are bloody, you want to make the other person bloody, so you will cut somebody because you want that person to look just like you. Part of our anger and frustration is that we have never dealt with the issues from our childhood. Therefore, we want to cut somebody in our adulthood so they can look like us, because we don't want to bleed alone.

This woman had an issue of blood. She had been bleeding all of her life. Truth be told, we try to act as if we don't have any issues and we are not bleeding. That is why you cuss everybody out, because you are bleeding. That is why you constantly replay in your head the words of someone dead and gone, telling you that you cannot make it. That is nothing but the blood bleeding through you. That is why you refuse to live out your dreams and take hold of your destiny. It is the blood loss in your life. When you lose blood, losing your life force, you are not at your best.

Bleeding Christians are the worst people to deal with because they always want to stain someone else, to take a little bit of the blood from themselves and place it on you.

This woman had an issue of blood. I love this woman. I love this woman because, if you want to stop the bleeding in your life, this sister gives us some information as to how to do it. If you want to clot what you have been losing, this woman gives us some information as to how we do this. That is what I love about this woman. At some point, you must come out of the shadows and take hold of your healing, take it into your own hands. At some point, you must leave the shadows and say, "I'm going to take my healing into my own hands. I know I've been bleeding. I know I have issues."

There must be a radical decision to take hold of your destiny. There must be. You may have been violated, but you will determine—by way of self-determination—you will determine your own life. You must make a decision to take hold of your own healing. No one is

going to do it until you make the decision: "I do not belong in the shadows anymore. I do not deserve this. I'm going to leave the margins of this world and make my way to Jesus."

One of the things that keeps us from being healed and keeps us from taking hold of our healing is that we bow down and worship at the altar of victimization. You've been bleeding, yes. There has been trauma, yes, but that trauma does not define you. That pain does not define you. You are more than your past. Your past does not define who you are. You cannot bow down to that moment. You need to break that idol and say, "I move from that margin and move into my destiny."

You may protest, "I can't get past it." It wants to keep you at a place where you are saying, "I cannot." But you know that you are more than that moment. You are bigger than your hurt. You are the master of your fate. You are the captain of your soul.

In the words of nineteenth-century poet William Ernest Henley, you can say, "Out of the night that covers me, / black as the pit from pole to pole, / I thank whatever gods may be / for my unconquerable soul. / In the fell clutch of circumstance / I have not winced nor cried aloud. / Under the bludgeoning of chance / my head is bloody but unbowed. / Beyond this place of wrath and tears / looms but the Horror of the shade, / and yet the menace of the years / finds, and shall find, me unafraid. / It matters not how straight the gate, / how charged with punishments the scroll, / I am the master of my fate: / I am the captain of my soul."*

If you do not know the poet, you can turn to the word of God, which states we are hard pressed on every side but not crushed, perplexed but not in despair, persecuted but not abandoned, struck down but not destroyed. You can leave the margins. Take hold of your destiny. Do you know you have the authority to step out of the shadows

*From *A Book of Verses* (London: D. Nutt, 1888).

and step into your destiny and be the person God demands you to be? Step out of the shadows.

Stop living where people have prescribed that you are to live. You don't have to live in that tent. You don't have to live in those margins. God has given you an opportunity. I love this woman. I love what she does. She steps out of the shadows.

Here is a question for you. What is your tipping point? When are you going to get sick and tired of being sick and tired? When are you going to get tired of living in the shadows? When are you going to get tired of people telling you who are you supposed to be and what you cannot do? When are you going to get sick and tired of people who are not doing anything in the first place trying to relegate you to some corner, to some space, to some dungeon?

At some point, you have to say, "I'm sick of this. I'm going to live and become the person God demands I become. I will step out of the shadows." You must move at some point. Will you get sick of it? Twelve years and you are so used to it you don't even see the blood stains on your soul. But everybody else sees the bleeding. You think the bleeding is normal. You have never lived your life in a moment when you were at full capacity because when you lose 10 percent, 15 percent, or 30 percent of your blood, you think that feeling is normal. Can you imagine, if the bleeding stops, the way you will feel, the way you will stand, and the way you will walk?

That's why I like this sister, and I know she's a sister. She has sister-like qualities in the way she rolls. I can see her with her sister-like movements, the way she walks, because she's bold enough to pass through and press through the crowd.

Even though she's got blood issues, she's going to push aside people who say, "You shouldn't be here." Even though she has issues, she's going to say, "Excuse me. I am trying to get to Jesus." If people try to hold her back, she says, "You don't know what I've been through. You don't know the kind of hell I've lived with and the dungeons I've come from, and the ditches I had to get out of in order to get here. You will

not stop me. You will not hinder me. I'm going to make it. I'm going to make my way to Jesus. You have no idea what my story is. Don't you look at me funny. I am making my way to Jesus. I'm not worried about you." She's a sister. She's making her way to Jesus.

Sometimes you have to be bold enough. Push past some people, the same people who pushed you in a corner. Don't even study them. You just step on through. Just slide right on through. Press on through. Duck on through. Do whatever you have to do to get to Jesus because it's a matter of life and death. You've been on the margin too long.

If I may paint this picture on the canvas of your imagination, I know this woman is a sister. I like the way she moves so smoothly. It says she comes in from behind. She's a stealth sister. She's like a SEAL team. She comes in there and says, "You don't know what I have to deal with." I can imagine her sliding between two brothers, and the brothers are trying to figure out what's going on here.

She says, "I'm not studying you. I have to get to Jesus." She can't even get to Jesus. She says, "If I can just touch the hem of his garment, I see it dangling everywhere he's going. It's moving. Every time I try to touch it, it moves away from me. Every time I try to get to it, I can't quite get to it. I'm going to reach it. I just need to get my index finger next to it. If I can't touch him, I'll touch what has touched him because I just have to be in his presence."

She's reaching, trying to get to Jesus. She can't touch Jesus, but she sees the hem of his garment dangling there, and she just—something happens. She did not even touch Jesus. She touched what Jesus was wearing. She did not even touch Jesus. She touched the cloth that he had on, and all of a sudden she felt power in her spirit. All of a sudden, all of the bleeding stopped, and she felt different.

I want you to know she didn't touch Jesus; she touched what Jesus had touched. She touched what was in connection with Jesus. If you can't get to Jesus, you need to find somebody who is in connection with Jesus. Do not try to act like you are here because you touched Jesus yourself. Don't you know it was somebody in your life who had

a connection with Jesus? It's because of their connection—just one degree of separation. I don't even need to touch Jesus. The residue of God is good enough for me. The overflow left in the saucer. I will drink from the saucer if I cannot get to the cup. I will get down on the floor and lap up the puddle. I do not need to get to him. I will take what's been next to him.

Truth be told, you didn't drink from the cup. You drank from the saucer. Somebody else had something in the cup; Mama had some overflow. Somebody else had something in the cup; Grandmama had the overflow. You just had the saucer, and the saucer was enough to remind you that Jesus has power, and you are a recipient of a saucer blessing. Don't ever act like you got the cup. You are a recipient of a residue blessing. Don't act like you have the cup. You are a recipient of the saucer.

Something happened. This woman felt power "immediately," the Word says. As soon as she did it, bam! This is what I like. I know she's a sister, because of what she does. Of course, the disciples do not know what is going on. Peter, as always, speaks out of turn. He's known for this, always opening his mouth at the wrong time. "Let's set up tabernacles here, Lord." "No, we're not doing that right now." He's always opening his mouth.

Jesus said, "Who touched me?" Peter, trying to act like he has authority—because, you know, he has insecurity issues. That's why he carries a knife. He says, "You are in the midst of a crowd. A whole lot of people touched you, Lord." "No. I felt power go out from me."

The Bible says that when the woman realized that she couldn't remain anonymous, she decided to fall at the feet of Jesus. She refused to be anonymous. Jesus asked her, "Who touched me?" She said, "I did."

If God has done anything in your life, you don't need to keep your mouth shut. If God has blessed you, you can sit there and act like you're so cute, but for the rest of us who know what the Lord has done, we will open up our mouths. We will give God praise. We will not remain anonymous, for the Lord has been good to us. Has the Lord

been good to you? Has the Lord blessed you? Then you need to open up your mouth. Let the world know what God has done in your life. Don't remain anonymous. Don't keep it on the down low.

If you look in Hebraic history here is more than likely what happens: The sister touched what is called the tallit. The tallit was similar to a shawl used to wrap oneself and pray. It was a prayer shawl. One would wrap the shawl around oneself and say, "I wrap this shawl around me just the way you wrap me up, O Creator." The shawl was made up of fringes and pieces of other garments. Possibly the sister touched the prayer shawl that had been wrapped around Jesus. She touched what had been wrapped around Jesus, and power flowed from the garment because it was the garment that Jesus used to pray with.

The woman refuses to be anonymous. Then something happens. When I read it, I got excited. The way Jesus answers is unlike the way he answers many times in the Bible. He doesn't say, "Woman, you are healed." That would be a designation of a woman to say, "I really do not know who you are." Jesus says, "I am going to answer differently because I know who you are, and I know what you have been through. I am going to answer you differently. I'm going to say 'daughter.' In other words, you're in my family. Daughter. You're under my protection. Daughter. I have authority to ensure that you are protected. You are my daughter."

You are a daughter. You are created by divine parents and included in a cosmic royal family. You are a daughter. There is authority resonating in your voice. You have power. You are a daughter. You are no longer an outcast. You are part of a cosmic family. When you know you are a daughter, you need to speak like a daughter, walk like a daughter, hold your head up like a daughter, have authority like a daughter, serve like a daughter, succeed like a daughter. You are a daughter of the most high God.

If our children knew they were a part of the divine family, if only our children really knew they were daughters and sons of God. . . . When you are a son or daughter, you know you have to be accountable

to somebody else. When you are a son or daughter, you don't want to bring shame on the name of your parents. When you are a son or daughter, you are going to operate in a different way. When you know you're included in God's family, I don't care if you don't know your family. I don't know care if you don't know your mama. You are a daughter of the most high God. You are a daughter.

"Daughter, you are healed." This is not a gender-specific edict. This edict is inclusive. Jesus is saying, "I am calling you daughter because I am including you in the family." When he heals a brother, he says, "Son, you are healed." He's saying, "I am bringing you into my family. Once I bring you into my family, you are under my rule. That means you're under my authority. If anybody messes with you, they have to deal with the parent. When the parent comes out, I have more authority than any other moms or dads you've ever run into. I am a holy parent. I'm the one that birthed you into this world."

What Jesus is saying is, "Welcome to the family, sons and daughters, men and women, rich and poor, black and white, young and old, gay and straight, urban and rural, ADD or PhD, UCC or AME, left or right, healed or infirm, married or single, divorced or betrothed, immigrant or native, prisoner or privileged, free or oppressed, speaking Spanish or Ebonics, if you know bebop or you like hip-hop, you are welcome in God's family."

God is welcoming you to the family. Welcome, daughter. Welcome, son. Welcome to the family. Welcome to God's house. Welcome to Trinity. Welcome to Jesus. Daughter, you are welcome. Son, you are welcome. The door of the church is open.

QUESTIONS FOR REFLECTION

1. "We all have issues." Name two or three of your issues and share how you are dealing with them.

2. How has Jesus been a detective in your life? What is he calling you to be or to do?

3. Jesus cares about children. How do you minister to children? How does your church? Is there more that can and should be done? Explain.

4. The woman in Luke 8:40–48 moved from the margin and shadows into her destiny. How are you moving into your destiny? What support do you need to more fully realize your purpose?

5. How do you welcome others into God's family? How is your church a welcoming community? Is there more that should be done?

SEVEN

THE GOSPEL ACCORDING TO
FOR COLORED GIRLS*

For Colored Girls Who Have Considered
Homicide When Jesus Is Enough

❀

SCRIPTURE: SAMUEL 13: 1–21

If you have your blueprints for salvation, the guide upon our journey, I would kindly ask that you would turn to the thirteenth chapter in 2 Samuel. I read from the New International Version today. It reads as follows, beginning with verse 1:

> In the course of time, Amnon son of David fell in love with Tamar the beautiful sister of Absalom son of David. Amnon became frustrated to the point of illness on account of his sister Tamar, for she was a virgin and it seemed impossible for him to do anything to her.

*The film, directed by Tyler Perry, who also wrote the screenplay, is based on the choreo-poem by Ntozake Shange, *for colored girls who have considered suicide when the rainbow is enuf* (New York: Scribners, 1975, 2010).

Now Amnon had a friend named Jonadab son of Shimeah, David's brother. Jonadab was a very shrewd man. He asked Amnon, "Why do you, the king's son, look so haggard morning after morning? Won't you tell me?"

Amnon said to him, "I'm in love with Tamar, my brother Absalom's sister."

"Go to bed and pretend to be ill," Jonadab said. "When your father comes to see you, say to him, 'I would like my sister Tamar to come and give me something to eat. Let her prepare the food in my sight so I may watch her and then eat it from her hand.'"

So Amnon lay down and pretended to be ill. When the king came to see him, Amnon said to him, "I would like my sister Tamar to come and make some special bread in my sight, so I may eat from her hand."

David sent word to Tamar at the palace, "Go to the house of your brother Amnon and prepare some food for him." So Tamar went to the house of her brother Amnon, who was lying down. She took some dough and kneaded it, made the bread in his sight, and baked it. Then she took the pan and served him the bread, but he refused to eat.

"Send everyone out of here," Amnon said. So everyone left him. Then Amnon said to Tamar, "Bring the food here into my bedroom so I may eat from your hand." And Tamar took the bread she had prepared and brought it to her brother Amnon in his bedroom. But when she took it to him to eat, he grabbed her and said, "Come to bed with me, my sister."

"Don't, my brother," she said to him. "Don't force me. Such a thing should not be done in Israel! Don't do this wicked thing. What about me? Where could I get rid of my disgrace? And what about you? You would be like one of the wicked fools in Israel. Please speak to the king; he will not

keep me from being married to you." But he refused to listen to her, and since he was stronger than she, he raped her.

Then Amnon hated her with intense hatred. In fact, he hated her more than he had loved her. Amnon said to her, "Get up and get out."

"No," she said to him. "Sending me away would be a greater wrong than what you have already done to me."

But he refused to listen to her. He called to his personal servant and said, "Get this woman out of here and bolt the door after her." So the servant put her out and bolted the door after her. She was wearing a richly ornamented robe, for this was the kind of garment the virgin daughters of the king wore. Tamar put ashes on her head and tore the ornamented robe she was wearing. She put her hand on her head and went away, weeping aloud as she went.

Her brother Absalom said to her, "Has that Amnon, your brother, been with you? Be quiet now, my sister; he is your brother. Don't take this thing to heart." And Tamar lived in her brother Absalom's house, a desolate woman.

When David heard all this, he was furious. Absalom never said a word to Amnon, either good or bad; he hated Amnon because he had disgraced his sister Tamar.

Another reading of verse 21 could be, "When David heard all this, he was furious, but he did nothing."

In 2010 Tyler Perry directed the movie *For Colored Girls*, which was based on the 1973 experimental choreopoem by black feminist Ntozake Shange, *for colored girls who have considered suicide when the rainbow is enuf*. Shange adapted her work for the stage in 1974 and it was later published as a book. The award-winning choreopoem/play consisted of a series of twenty poems performed by a cast of seven women. It expressed in visceral, colorful dialect struggles experienced

by black women in America, particularly regarding love, abandonment, abuse, abortion, and rape. Although the various characters, named simply as being dressed in various colors—lady in red, lady in blue, lady in orange, and so on—suffer alienation and abuse of various kinds, in the end they come together and find empowerment in their womanhood.

The language of *For Colored Girls* is at times harsh and the topics difficult, but the film shares themes of abuse and abandonment and rape with the biblical story of Tamar, and perhaps with someone you know today, and that is what we will explore.*

I have been engaged in prayer about this story and, Beloved, there are moments, fleeting moments, infrequent, when the horror and holiness of the Bible take place and take hold on one's heart and soul. There are moments, however few, when the characters pressed between the pages of the parchment begin to speak.

One writer describes how fictional characters of a place about which she was writing began to speak to her spirit and took residence in her house. As I prayed and sought to run from this subject, Tamar and her spiritual children kept knocking at the door of my imagination. I was compelled to let her enter, and she quietly entered my home and sat down in the living room and said to me, "I have a story to tell."

Her voice was not of a woman desolate or broken, but of a woman strong, yet worn, by the years of carrying the burdens manufactured by others. The weight of her life was evident. The ashes stained her cheeks and left dark residue on her fingertips. I sat and listened. At times I had to hold back tears as she spoke with a worn assurance. She came by for weeks, giving new details and insights into her story.

The last time she came by and made an appearance, she smiled at me and said, "Tell my story." I immediately responded with nervous fear. I said, "I can't tell your story. I am a man. I cannot tell your story.

*When this sermon was delivered at Trinity, the church's drama ministry powerfully performed excerpts from the choreopoem as a lead-in to the sermon.

I am nothing but a preacher. I cannot tell your story. There are those who are better equipped to tell your story than I."

She responded with a kind, yet stern, look and said, "My story will not end, Otis, until men—not just women—tell my story and understand that no one should be cursed with the memories that I have on the dark side of my life." I promised her that night that I would do my best. I made a promise to tell her story. I recorded her words and attempted to frame them in the best way that I can within the context of her situation.

And from the catalog of our conversation came this: She said to tell you the ordeal that she underwent changes you. She said, "It changes you. It is what you mark as the 'before' and the 'after.' There was one way you lived before and there is another way you live after. The world tumbles in. The weight you carry is enough to break Atlas as he carries the world. Your soundtrack changes. The light vibrant chords are painted blue with sorrow, red with rage, and amber with your anguish."

The morning of her life became dusk. Night chased away morning. Every time the door opened, she thought there was joy but the night would come and snuff out every candle she would light in the dark. "It changes you," she said. She wanted to be the young girl again. She wanted to be the princess of the palace, the girl before it happened. She was happy, joyous even, and described herself this way: "I was a princess living in the palace, with servants at my beck and call." She wished she could go back to before, but the cruelty of the memory in her would not allow her to do so. That is the cruelty of memory—you can remember what used to be, but you can never return to what you used to be. Since that day she has struggled with trying to put her life back together and make sense of things.

She told me several times in conversation that she almost let go. She almost committed suicide because it was too hard to walk around the palace and see the one who violated her walking free and laughing with his friends. But something in her spirit said "No, I will not give up and I will not give my spirit over to the one who bruised me."

She kept asking the question, "Why did it happen?" She admitted that she was angry with God and it took her years to come to grips and come to a simple revelation. "It was not my fault, and I tell you this," she said, "Tell them, Otis. Tell them that they have been fed lies about violation. You did not cause it and God did not ordain it. It was not your fault. No matter what you wore, no matter what you said, do not believe that lie from the pit of hell. You had nothing to do with it. No one deserves to be violated. God did not ordain your pain and God did not endorse nor sign this evil. You have been lied to, usually by men standing in pulpits claiming that they are people who support God. Stop this day believing that lie. Whatever you have been told, you need to know it wasn't your fault."

And she raised this question: "How could this happen to a princess? I was the king's daughter," she said. "How could this happen to me, one who had the protection of the palace guards? And it was my brother and a cousin who took advantage of me."

She said that, as she began to reflect upon her life, she came to realize the kind of matrix she was in; she lived in a beautiful palace, a gorgeous home that people dreamed about living in. But she lived on the outside. It looked like a mansion but there were monsters walking around inside. She lived in a dysfunctional household. She did not understand at first, but she came to understand that she lived in this dysfunction. The danger of a dysfunctional family is it can corrupt your spirit if you are not willing, in the words of one writer, to swim to the top of the rain.

Her father, as you know, was David. He was adored by thousands. Men wanted to be like him and women wanted to be with him. He was David. No one had a swagger like him. David could destroy thousands with his sword and commanded men just by giving an order. He was the greatest king that Israel had ever seen. Anyone in the shadow of his charisma was taken away by his gifts. He was a musician. He was a poet. He was a speaker. He was a leader. He was the most gifted king that they had ever known.

He was a failure, however, as a father. He could present himself well in public, but something else was happening behind closed doors. As Tamar began to rewind the life of her father, she remembered that he came from a dysfunctional family, and that her father, David, had spent his life trying to get the attention of his father, Jesse, who did not believe his youngest son had the gifts required to be king.

And David, like many men, was a combination of ego and insecurity, always trying to live beyond the words that he heard in his childhood. "I don't have any more children who can be anointed king. Well, there's that runty one out in the field, but you wouldn't want him." Tamar came from a dysfunctional family.

There is a danger in dysfunction, because if you live in dysfunction long enough, you will think your dysfunction is functional. You will begin to make what is dysfunctional normative, and you will think other people are crazy when they are in a functional relationship.

There's a danger when you spend so much time around dysfunctional people, and then there is the problem of everybody who is a fan but not a friend wanting to be where you are because they see the palace guards, they see the ornamented robes, they see the servants, they see the chariots. They want to be where you are, yet they do not know that there are monsters walking around in the mansion. There's a danger living in a dysfunctional family.

As we talked, Tamar quoted the great poet from Philadelphia by the name of Sonia Sanchez. She said that it is one thing to be wounded but the most dangerous, most painful thing, is to be wounded in the house of a friend—to be violated at home. You can make sense out of violation done by a stranger, but when it is people who say they love you but then violate you, take advantage of you—that completely messes up your idea of what love is. It's that kind of violation that cuts so deep into your spirit that, even after it heals, your scar will always hurt.

It is that sort of violation that Tamar endured at home, committed by her brother, Amnon, and a cousin, Jonadab. Both conspired to violate her, conspired to destroy her, conspired to break her. Statistics

show that one in six women will experience someone attempting to violate them. And one in thirty-three men will experience someone trying to violate them. The stats for men would probably be higher were it not for the fear and hesitance to report this sort of abuse.

Violation is rarely committed by a stranger, but usually comes from people with familiar names: uncle, father, cousin, brother, mother, aunt, sister, friend, lover, husband, wife—names we are familiar with. Violators conspired to steal Tamar's humanity. What kind of sick mind conspires to steal someone's humanity? What kind of sickness dwells in someone's spirit and causes that individual to want to destroy his or her own blood?

And so, yes, it was her brother; yes, it was her cousin who violated Tamar. But the thing that brings tears to my eyes every time is this—she was violated by her father. David knew but he didn't do anything. David knew that his baby had been violated. He was privately angry but he did not want anybody publicly to know because his political career was more important than his family. Therefore, he kept it on the down low.

Can you imagine the magnitude of Tamar's hurt? She watched her father—the one who was so smooth with a sword, and could soothe a man who was mentally ill with his harp, who had killed tens of thousands, who was a military leader, who was strong and swift— do absolutely nothing when it came to protecting his own daughter.

That's the kind of scar that it is difficult to be liberated from. When you have seen the person who was supposed to protect you, and who has protected so many other people, fail to protect you. When you have seen that person stand up for everybody else, but not speak up for you. When you've seen that person stare down everybody else, but not step in front of the punch for you. When you've seen that person stand up and give his entire spirit and soul to everybody else, but not do it for you. There is something that happens when you are subjected to this kind of hypocrisy that rips out your very humanity.

Tamar saw her father do nothing. I love Tamar because Tamar has a revolutionary spirit. She realizes that "since my daddy won't stand

up for me, and since Absalom won't stand up for me, I'm going to have to stand up for myself." If you read the text, she does something that you could completely miss. She does something so revolutionary. She has a subversive womanist theology. It's in the way she moves.

She says, "If you're not going to do anything about it," then she takes some ashes and puts them on her forehead. She rips her robe. If you will recall, sackcloth and ashes are to let everybody know that you're going through something. Tamar wanted everybody to know that not everything was right in the palace. "I know you hear my daddy giving the speeches, but when you see me walking, I'll be wearing sackcloth and ashes. They may not speak up for me, but I will speak for myself."

Be careful. Do not judge folk according to how they dress and what they say. When you see them, they may just have on some sackcloth and ashes. They want to let you know that they have been through something. And if you had only witnessed a glimpse of their pain, it would have driven you crazy.

And every day we walk, whether to work or coming into church— I know you have your Sunday best on—however, I still see some sackcloth and I see some ashes. I see some people who do not have a fairytale life, people who have some pain so deep it would kill someone else. However, by the grace of God, you are here speaking, praising, worshiping, working through everything you have been through.

Many of you have heard of a gentleman who has now become very popular in the news. His name is Ted Williams. Ted Williams was homeless one day, but he always held his sign, his sackcloth and ashes. He said, "I've been through some stuff, but I have a golden voice. And if you give me an opportunity, I will show you that my voice can do great things."

There was a reporter in Columbus, Ohio, who saw Ted Williams on a corner begging for some money. And he said, "Tell me about this golden voice." And Ted started to talk and that little clip went on YouTube and went viral. Then the Cleveland Cavaliers hired him. They

gave him a brand new job, but not just a job. They gave him a brand new house. Then after the Cavaliers gave him the brand new house, Kraft Foods called him up and said, "We need a national spokesperson. We need somebody to be a voice for us who can speak across the world."

But as my family and I—Monica, Elijah, Makayla, and myself—were watching YouTube and watching an interview with Ted Williams, he said something that about made me cry and shout at the same time. Ted was talking to the interviewer, when he said, "With all that I've been through and all the stuff that I've done and all the challenges that I've had, I never lost my voice; God kept my voice."

With all that you've been through and all the challenges you've had, with all the hurts that you've experienced, with all the dungeons you've been through, you haven't lost your voice. Do not give some pitty-pat praise. Praise God for what the Lord has brought you through! If you have your voice, open up your mouth and tell the devil he's a liar!

"I still have my voice! I may be homeless, but I have a voice. I don't have a job but I have a voice. I am not sure what tomorrow holds, but I have a voice. And I will bless the Lord at all times. His praise shall continually be in my mouth. I have a voice." Never lose your voice.

What I like about Tamar is that she tears her robe, an ornamented robe, the robe given to her by her father. The king gave her a robe, one that only goes to a princess. Whenever you have on this particular kind of robe, people will move out of your way because they recognize that robe as a symbol of your relationship to the palace. There are people who will show up on your behalf because you have on the robe. Tamar tore the robe. She didn't take off the robe. She tore the robe. The relationship was raggedy, but she was still a child of the king.

And I am here to let you know that your robe may be torn but you've still got it on. The relationship may be raggedy, but you got your robe. And everywhere Tamar went, she had on sackcloth and ashes, but she had her robe. She was still a princess. She still had privileges

in the palace. She was still a child of the king, and no one, no matter what they had done to her, could take that relationship.

No matter what has happened, nobody can take your relationship with the King. No violation, no demon, no fool in your life, no Negro, no Negress, no job, no preacher, nobody in your family can take it away, because once you have been birthed into this world by God, God claims you forever. You are a child of the King.

I have to tell you one more thing: When you have your robe on, when you still have your voice, you can speak to your violator with such authority that you can let him or her know that he or she cannot destroy you.

One of the favorite movies of my wife, Monica, is a movie called *The Color Purple*, which we have preached about previously. Monica knows just about every line in the movie, and there is one scene in the movie that Monica can repeat and shout at the same time.

If you don't know the movie, Celie, played by Whoopi Goldberg, was abused by Mister, played by Danny Glover. And there is a scene at the dinner table where Mister, who has been abusing Celie throughout the whole movie, is about to rear back and punch Celie. Something wells up in Celie when Mister is about to hit her. He's about to hit her, but Celie gets her voice and . . . something shifts in Celie's spirit and she realizes, "I have my voice."

Mister is frozen and then tries to hurt Celie verbally. He says, "You're poor. You're black and you're ugly," but I like what Celie says back to Mister, "I may be poor. I may be black. I may be ugly, but I'm still here." Have you ever been through dangers, toils, and snares but you're still here? God has kept you, and you are still here. Let the devil know he took his best shot, but you are still here. "You tried to destroy me, but I'm still here."

QUESTIONS FOR REFLECTION

1. The church is too often silent on the subject of domestic violence and violation. Yet the Bible does not shy away from this difficult subject. How should the church respond to situations of family violence and abuse?

2. David was a combination of "ego and insecurity." In what ways are you like David? How does this combination play out in your relationships with God? With others?

3. Tamar does not run from her situation. She lets the world know that she has been violated. How do you stand up for yourself? How do you stand up for others?

4. David is the greatest king in Israelite history. How do you feel about David's inability or unwillingness to stand up for his daughter?

5. How can you be a friend to someone who has lost her or his voice or had that voice taken away?

EIGHT

THE GOSPEL ACCORDING TO
THE BOOK OF ELI
When a Black Man Knows the Word

❀

SCRIPTURE: HEBREWS 11:1–6; 2 CORINTHIANS 5:7

I f you have your blueprints for salvation, the guide upon our journey, the rudder of our ship, the wind in our sail, I would kindly ask that you turn to the book of Hebrews in the New Testament. I want to read from several different translations. Our passage begins with verse 1 in chapter 11. It reads this way from the New International Version:

> Now faith is being sure of what we hope for and certain of what we do not see. This is what the ancients were commended for.
>
> By faith, we understand that the universe was formed at God's command, so that what is seen was not made out of what was visible.
>
> By faith, Abel brought God a better offering than Cain did. By faith, he was commended as a righteous man, when

God spoke well of his offerings. And by faith he still speaks, even though he is dead.

By faith Enoch was taken from this life, so that he did not experience death; he could not be found because God had taken him away. For before he was taken, he was commended as one who pleased God. And without faith it is impossible to please God, because anyone who comes to him must believe that he exists and that he rewards those who earnestly seek him.

A different translation from the New Revised Standard Version reads this way: "Now faith is the assurance of things hoped for, the conviction of things not seen." Another translation, the King James Version, reads: "Now faith is the substance of things hoped for, the evidence of things not seen." 2 Corinthians 5:7 reads in the NIV version: "We live by faith, not by sight." Another translation is: "We walk by faith, not by sight."

Beloved, faith is the very substance of the divine. Access to the holy is reached through faith. Faith, one could say, is the cosmic ingredient within God's divine concrete, which becomes the foundation of dreams destined to become reality. Faith is the power to see without eyes and hear without ears. Faith is the back beat of our religious life and the central chord of our spiritual development, the primary element of human growth. Faith is the invisible, intangible element that brings men out of addiction, women out of abuse, and children out of dysfunction. Faith is a deep abiding trust in God. Faith is the key to reversing tragedy and turning it into triumph.

By faith, Harriet Tubman led three hundred enslaved people of African descent to freedom. And by faith, Frederick Douglass moved from a slave to becoming an abolitionist. By faith, Sojourner Truth received her name and was able to stand before men and women and ask, "Ain't I a woman?" By faith, Booker T. Washington walked into a small town called Tuskegee, proclaimed it and claimed it for God, and

set up an institute that still educates and graduates men and women to this day. By faith, T. Thomas Fortune became a prophetic journalist and the ghostwriter for Booker T. Washington. By faith, W. E. B. Du Bois was able to write probably the greatest sociological work of the twentieth century, *The Souls of Black Folk.*

It was by faith that Ida B. Wells was able to walk through the South and record lynchings and write about the horror many people of color faced. By faith, Marcus Garvey was able to found the Universal Negro Improvement Association and organize more than 2.5 million people of African descent. By faith, through many dangers and toils and snares, we have come through by faith. Faith is how we access God. Without faith, it is impossible to please God.

And when we examine this particular writer's intent in Hebrews, we understand that this scripture is different from other epistles. Paul usually writes a pastoral epistle, a letter directly to a church. However, this writer is not writing in that traditional vein but is writing more as a preacher. One can hear the nuances as one reads the Letter to the Hebrews, can hear the ear and the cadence of a preacher who is giving a run on faith by saying that, without faith, it is impossible to please God. By faith, Noah was able to commit to God the unseen and build an ark. He keeps talking about faith in this poetic narrative, while simultaneously trying to help people understand that, in order to access God, one must have faith.

One can imaginatively hear the writer of Hebrews as he preaches this sermon and says, "Faith is the substance of things hoped for, the evidence of things unseen." Or "Faith is the assurance of things hoped for," depending upon your translation. The word "substance" or "assurance" is in Greek the word *hypostasis*, which means "the very being of God." Faith is the very being of God. If you want to access God, you have to have faith, knowing that you are accessing the very being of God. What the writer is saying is that the promises of God are already at work, even though you don't see the promises in your life right now.

God has already sent an advanced team on your behalf. Therefore, if you have faith, then you can celebrate in your present for what is coming in your future because you already know what has happened in your past. You have already seen God operate in the past. Therefore, you can celebrate in the present knowing that God will do it again in the future, even though you haven't seen it yet. I celebrate now knowing what God has done. Therefore, I can praise God right now for what God will do. I do not have to wait for the future. I can do it in the now because I've seen it in the past. So I can shout now for what God will do. I don't have to wait for deliverance. I know that it's coming because God has already delivered and will do it again. Even though it has not happened right now, I will shout right now. You can celebrate what God has already done, and you can shout right now for what God is *going* to do in your life, even though it has not happened. Can you give God praise for what God is going to do? Faith is the substance of things hoped for. I don't see it yet; however, I know that it's coming, and I'm going to act like it has already come.

You are wondering why I hold my head up in the midst of my storm. It is because I know the storm will eventually be over. I am going to get in practice right now, so that I can shout later. Well, I guess if I may parenthetically put it this way: Even if what is hoped for is not here yet, I'm willing to shout on credit. That means I may not have the money right now. Please do not look at me funny, because a lot of you have bought stuff on credit. You do not have the money. You cannot pay for it right now, but you know that you will be able to pay in the future. Faith is the substance of things hoped for. It is the evidence of things I cannot see.

This scripture and this film seem to collide theologically. I enjoy and love movies, and I especially love this film, *The Book of Eli*. For those of you who have not seen it, I would encourage you to go down to your local video store and get a copy and watch it twice. The film stars Denzel Washington. (Calm down, now, I did not say

Jesus. I said Denzel Washington. They're shouting, falling out already, shouting over Denzel. You never met Denzel, but are shouting, anyway.)

The Book of Eli stars Denzel Washington and another wonderful actor by the name of Gary Oldman, who plays the character of Carnegie. The film is masterfully directed by two African American brothers by the names of Allen and Albert Hughes. The film is a journey film. It is a self-discovery film, and it has elements of a spaghetti western. And it also has elements of a lone samurai film, such as those done by Akira Kurosawa.

The central theme of the film amazes me. The main character, played by Denzel, is a gentleman by the name of Eli. Eli has the last Bible in a postapocalyptic America. This black man has the last Bible in America. He has been charged by God to protect the word—to do whatever he can to stay on the path and to protect the word as he journeys west. He has to stay on the path because he has to protect the word. And it says in the film that he wanders thirty years in the wilderness, studying the word for thirty years.

Every day, this black man—who has the last Bible on earth, who has been charged by God to keep the word, to protect the word—studies the word, every single day. God says to him you are to go west. God gives no details of what he will encounter when he goes west. God's just saying, if you trust me, you will walk by faith and not by sight because I have entrusted you with the last Bible on earth. Then, as in every film, a conflict takes place. The conflict happens between Eli and Carnegie. The film puts faith in conflict because in the midst of this film, Gary Oldman's character, Carnegie, who is the antagonist, wants the word from Eli.

He wants it for himself because he recognizes that, if he has the word, he can exploit the word and enslave other people. The only two people in the movie who can read are Eli and Carnegie. They are the only two people who can read. So Carnegie wants to take back the word, saying it really belongs to him. Eli tries to stay on the path going

west, yet he ends up in a conflict. Whenever you make a commitment to God based upon your faith, you are in conflict with the world.

The temple of faith that you enter into will always put you in conflict with the church of fear. The enemy of faith is always fear. Fear claims he knows the outcome. Faith claims that God has the last word. Carnegie wants the word for himself. He wants to rule by fear because if he has the word, and he's the only one other than Eli who can read, he can tell people what's in the word.

He doesn't want anybody else to read the word because he intends to exploit everybody. He doesn't want them to read the word for themselves because, if they read the word for themselves, they will recognize that his interpretation and his strange proof-texting do not fit theologically with the gospel of the word. This scenario sounds very familiar to me: Somebody wants to make sure that other people do not read the word because, if they read the word, they will skip over "Slaves, be obedient to your masters" and find out that Moses said to Pharaoh, "Let my people go." If I begin to get into the word, I will begin to understand what it is that God is saying in my life.

And so Carnegie wants the word from Eli, and Eli says, "No, I have to stay on the path. You can't have the word because God has spoken to me to say that I should protect the word, and I'm taking the word west." Clarence Jordan, the great preacher from the U.S. state of Georgia, now long gone, had this to say about faith and fear, a saying that arrested me. He said, "Fear is the polio of the soul, which prevents our walking in faith. Fear seeks to crush your spirit and get you to give up your dreams. Fear will tell you you can't, but faith says, yes, I can."

Fear says there is no need to pray. However, faith says pray without ceasing. Fear says hold back your tithe. But faith says bring all the tithes into the storehouse. Fear says voting is a waste of time. But faith says that, if you vote, you can rewrite the Constitution with a Thirteenth, Fourteenth, and Fifteenth Amendment and insert a Voting Rights Act. Fear says you can't elect a president. But faith says you can

elect a president. Fear says you can't reform health care. But faith says you can reform health care. Faith says you can close Guantanamo Bay. Faith says that you can stop torture in the United States. Faith says you can regulate Wall Street. Faith says you can bring troops home from Iraq. Faith says you can stop the recession. Faith says you can put two women in the Supreme Court. Faith says you can win a Nobel Peace Prize. And faith says you can do more in two years than somebody did in eight. Faith the size of a mustard seed. Without faith, it is impossible to please God.

Fear is a dangerous thing. And I say to sisters that you have to watch out for fear. There is a fear running across the land, there are some people who will lead you to believe that all men are dogs. That is an act of fear. However, faith says you just need to stop dating at the kennel. If you want to live a life of faith, you cannot operate with a spirit of fear.

In this day and age in America, America wants to choose fear over faith. That is what concerns me about our brothers and sisters who are part of the tea and coffee party because they operate with a spirit of fear. Fear of brown people coming across the border. Fear of a black person in the White House. Fear of same-gender-loving people moving next door. Fear of women. Fear of anyone who does not look like they do or believe what they believe. The spirit of love drives out all fear. God did not intend for us to live a life of fear. The question for us is, how are we going to live a life of faith in the presence of fear?

We find out something in the film. What is fascinating to me is we find out within the film that faith is infectious. When you live a life of faith, you will infect the next generation. I was watching the movie, and this realization blew me away. I get excited in movies. I said, "Oh, Lord," when I saw the scene where Eli is headed west, and he's protecting the word. Carnegie, who wants the word from Eli, says to Eli, "You will be a guest in our town."

However, Eli says, "No, I have business to take care of. I'm on my way west." Then Carnegie says, "No, no, no, this is not a request. You

are going to be a guest in our town." Next they give Eli food and water and a bed. This is postapocalyptic America; something has destroyed all of society, and water is hard to come by, food is hard to come by, a warm bed is hard to come by, shelter is hard to come by. They're trying to figure out what Eli would want in exchange for giving up the word. Finally, Carnegie sends a young girl as a prostitute into Eli's room. But, you see, they don't know what really drives Eli.

So, this young girl comes in specifically to sleep with Eli. However, instead of sleeping with her, Eli offers her a meal of bread and libations. He offers her a meal similar to communion and sits her down. She's about to eat, but Eli says, "Hold up, don't you eat yet. There's something we have to do before you put of morsel of food in your mouth." She says, "What do I need to do?" And he says, "Come here; give me your hands." And they hold hands and he starts to pray. Then they eat. The unique thing is that when this young girl, named Solara, goes back to see her own mama, she remembers what this black man did for her and begins to pray in the presence of her mother.

Because of her connection to a man who knew how to pray, she starts teaching other people how to pray. When black men learn how to pray, it is powerful. If you want to bless another generation, if you want to bless young people, show them a brother who knows how to pray. It does something to their spirits. When I was young, I remember seeing my father on his knees praying, and that image arrested me. It is with me to this day. A praying man made me understand at that moment, as a young child, that real manhood is rooted in your spiritual connection. My father recognized there was something bigger than him. There was somebody bigger than him.

When a black man learns how to pray, he will bless his family, and he will bless other people. Do you know the power of prayer, brothers? Do you know that you didn't get here because of your degree? You didn't get here because of money in your pocket. You got here because you know how to pray, and somebody prayed for you. You are a by-

product of prayer. There is power when brothers begin to pray. If you are somebody's son, it is your duty to make sure that you teach someone else how to pray.

When you do that, you will bless the lives of people who have not yet been born. When a brother begins to understand the spiritual power of prayer—and in the film Eli teaches a young girl how to pray, and she teaches her mama how to pray—you will pass on that spiritual lineage to someone else. And so faith is always infectious. Faith is the substance of things that are hoped for. The evidence of things not seen. The thing about faith is that faith is never rooted in the material. It says here in the text that it is by faith, not by money, not by material things, not by your education, it is by *faith* that Abel was able to give an offering that was pleasing to God.

It is by faith that Enoch was taken not by death but went straight up to heaven. By faith, Noah was able to build an ark, even though he had not seen rain flow in his community like God promised it would. By faith, Abraham was able to walk to a land he had never been. It was not based upon the material; it was based on the spiritual. When you develop your spiritual muscles, when you recognize that faith is not rooted in the material, the enemy cannot remove things from you and then say, "Give up on your God."

The same thing mentioned in relationship with Eli also happened to Job, where the enemy said to God, "The only reason that Job serves you is because Job is living high on the hog. He has houses. He has land. He has all kinds of cattle. He has a family. He has good health. If you take your hand off Job, he will curse you and die, because he does not love you just because you are God. He loves what you've given him. And if you remove that, then he will no longer love you because his theology is material theology."

God said, "I will take my hand off Job because Job is a good man. I know Job a little bit better than you." So God says to the enemy, "You can take whatever you want from Job, but don't kill him." And so the enemy takes his family and Job is crushed.

Job then moves into an economic recession. All of his cattle are gone because of an economic crash in his life. His house is torn up. Then Job loses his health. My father says it this way: Job became so sick, flies refused to land on him. Job was sick, no family, no housing, and he'd lost his money. However, Job says something that blows me away. "Naked I came from my mother's womb. Naked I will return there. The Lord giveth, and the Lord taketh away. But blessed be the name of the Lord."

Even though God has removed stuff from me, though he slay me, yet will I trust him because my love for God is not based upon the material (nothing that anybody can manufacture). It is not based on that. You can remove all of this from me, but I will still love my God. If he never does anything else for me, he's already done enough for me because I love him whether the sun is shining or whether I'm in the midnight hour. I love him when I'm weeping, and I love him when I'm shouting. I love him when I'm sick; I love him when I'm well. I love him when I'm down; love him when I'm up.

That is the kind of relationship you want to have with God. You don't want to have a fair weather kind of faith. I want to know, can you serve God when you are at your lowest point? I want to know, can you serve God when you cannot see the light at the end of the tunnel? I want to know, can you serve God when it does not seem as if there will be a good diagnosis, yet you still know that God is God? You know that you serve God and you will still give God praise because God is God, all by God's self.

Can you praise God, not for what God's done for you, but because God is God? That first is conditional faith. And if I remove the conditions from your life, you will lose your faith.

In the words of one woman who was in the hospital dying with cancer, as she said to Dr. Charles Booth, "I know my God is a healer. He is yet to heal me, and it looks like he never will. But I will go to my grave knowing my God is a healer."

My faith is not based upon what God does in my life, because I have witnessed God move so much in your life and in your life and in your life that when I wake up and open my eyes in the morning, even if I have a pallet out in the street, I still know that the canopy of heaven is above me, and the earth is below me. I still can feel the wind upon my face and hear the sounds of birds in my ear and smell the flowers upon the ground. I know I do not have the power to make it, but I can still say about God, great is thy faithfulness.

Do you have that kind of faith? For there will come a time in your life when God will not answer the prayer, when the door will not open, a time when you will seek and you will not find. Will you still love God then? It's not based upon the material. That was Carnegie's problem in the movie. He thought faith was a substance of things you could see. The evidence of things you can touch. But Eli says to Carnegie, "I walk by faith, not by sight." You really don't know what drives me. You may see what I'm driving, but you don't know what drives me.

Faith demands that we see beyond our circumstance. There is a story that I've heard several times that's so powerful, it moves me in my spirit. It's a story that took place after World War II, just after the war was over. The American forces were moving through Germany looking for snipers in the rubble in a city in Germany. They happened upon a basement, a hidden room where small Jewish children were hidden. They took those children out, I'm told, and when they went looking in that basement, they found something that brought the soldiers to tears. A little boy, fearful of the Nazis, had taken a piece of chalk in the darkness of this basement and had written on the wall, "I believe in the sun when it doesn't shine. I believe in love when it's not shown. And I believe in God when he does not speak."

Can you see beyond your circumstances? Can you sing gospel when everybody else wants you to sing the blues? Can you begin to shout even though you don't know when your deliverance is coming? We must operate and be able to turn over the mess that the world dumps upon us and turn it into something new.

There's a story that Howard Thurman told often about his mother and what a powerful influence she was upon him when he was growing up. His mother was a landowner in the South in the 1920s. As a landowner in the South, she had her land juxtaposed right next to a woman who was not of color and who did not like the fact that this colored woman owned land. Ms. Thurman had all these beautiful plants outside. She was a farmer. She had some greens, and she had some tomatoes, and she had some sweet potatoes. She had all kinds of things outside right next to the fence of this woman who could not stand the fact that a black woman owned some land during a time period when people of color did not have rights in the Deep South. This colored woman, how dare she move next to me?

And so this woman decided to do something about it. This mean woman got a bucket and went into her own chicken coop and took the bucket and scooped up all of the stuff that was on the floor. And she dumped everything into Ms. Thurman's yard. Dumped it on the greens, dumped it on the tomatoes, dumped it on the sweet potatoes, dumped it on the okra. Dumped it on everything. Dumped it on her flowers and dumped it on everything she had out there. She dumped on her.

What the mean woman didn't know was that Sister Thurman was a woman of faith. She knew how to take whatever anybody throws on her and turn it to her benefit. And so she got down on her knees and started praying to God saying, "God, somebody is dumping on me. What do I need to do?" The stench of what they're dumping on me is floating into my house. The Lord spoke to her and said, "Sister Thurman, go get your shovel." She said, "What do you mean?" He said. "Go get your shovel. I'm going to show you what to do." And so the Lord instructed Sister Thurman to go out into the garden and take her shovel and turn everything over. So every night, she would turn stuff over.

In the morning the woman would dump, and in the evening Sister Thurman would turn it over. In the morning her mean neighbor

would dump, and in the evening Sister Thurman would turn it over. Then the Lord said, "Don't just turn over. I want you to go down the street and get some seeds, and take those seeds and put them into the ground where she's been dumping on you." So she put those seeds deep into the ground. Several weeks later, something started to come up. Roses started to come out of the ground. All of the stuff the mean woman had been dumping ended up becoming the basis for growing something beautiful in Ms. Thurman's life. And eventually the woman stopped dumping.

Now, Ms. Thurman couldn't figure out what happened. Come to find out, the woman was sick. She wasn't just mean to black folk. She was mean to everybody, and when she was ill, nobody wanted to visit her because her spirit was anemic. Sister Thurman, who was a woman of faith, decided she was going to go by and see the woman anyway. However, before she went by, she decided to bring a gift. So she went out into the garden, the same garden the woman had thrown stuff on. She took some little scissors to cut these roses, twelve of them, and she took them next door. She knocked on the door and heard a frail voice tell her to come on in.

The frail, ill woman was so thankful that Sister Thurman had come by to see her. Sister Thurman placed the roses right next to the woman. And the woman asked why would you do this? No one comes to visit me. No one in my family has even come to visit me. Here I am on my way to cross over, and the one person I've been so mean to is the one who visits me in my hour of need. Finally, she stopped talking for a moment and looked at the flowers. She said, "Those are the most beautiful roses I've ever seen in my life. Where did you get those roses?" Sister Thurman smiled and said, "Well, you helped me make them because every time you started dumping on me, I learned how to turn it over."

When you have a connection to God, it does not matter what the enemy dumps on you. God will give you the resources to turn some things over in your life. You can take what you thought was destroyed and God will give you something new to plant that is even more beau-

tiful than what you planted before. When we look at the film, we see that Eli loses the book that he has been protecting. When he lost the book, I got so upset!

I said, "Brother, you've been protecting the book for almost two hours. How could you lose the book? It's the last Bible in the world!" However, Eli keeps on going west. He keeps going west, and I keep watching, saying, "Why are you going west? You don't have the book; go back; get the book. You have a sword, take everybody out, get the book, then go west." That's the Otis Moss version. However, Eli said, "No, I'm going west without the book." He goes west and eventually he and the young woman Solara make it to San Francisco, and they find out that there is an enclave on Alcatraz where people are collecting all of the books that have been lost in the war. He makes it to Alcatraz. Alcatraz has another name; it is called "the rock." He makes it to the rock.

When he gets to the rock everything will be all right. When he gets to the rock, there will be food and shelter. When he gets to the rock, there will be water. When he gets to the rock, there will be safety because there are people who are on the outskirts of the rock to make sure that no one is hurt trying to make it to the rock. He makes it to the rock, and when he gets to the rock there are these men pointing guns at him because they're worried that he may be there to rob them.

They hold guns at him and, as he stands up with both hands up, he says, "I'm in possession of a King James Version of the Bible." I was so relieved. I said, " Oh, Denzel had a second Bible." I said, "Go ahead, Denzel, you the man." He must have a second Bible. I'm waiting for him to pull out the Bible and say, "I have a second Bible; they didn't steal the Bible from me," but he never pulls it out. Then the person who runs the rock says to him, "We are trying to collect all books but there's one book that we've been looking for. There's one book that we need in the collection. We found everything, but we don't have a Bible." And he asks Denzel, "What condition is it in?"

Denzel says that it's battered but it will do the job. And I'm still looking for him to pull out the book. He doesn't ever pull out the book. What I found out is that while Denzel was wandering through the wilderness for thirty years, studying the word every day, the word was in him, and when the word is in you, you can bring it back and resurrect people. And when the word is in our brothers, when the word is in our community, fathers will raise their sons. When the word is in you, brothers will commit to their wives. When the word is in you, you will mentor your boys. When the word is in you, you will organize at your school. When the word is in you, you will see brothers returning to church. When the word is in you, I see men committing to Jesus. When the word is in you, we'll have another Malcolm, Martin, and Medgar. When the word is in you, the Holy Spirit will move in our brothers and there will be a transformation in our community.

Something happens when the word is in a black man. He'll stand with authority. When a black man has the word in him, he will stand with authority. Is there a brother who wants to stand, who has the word in him?

According to Isaiah 40:31, even youths will faint and be weary; and the young will fall exhausted, but those who wait upon the Lord shall renew their strength. They shall "man up" with wings as eagles. They shall run and not be worried. They shall walk and not faint.

When a black man has the word within him he will stand up with authority: "Thy word is the lamp unto my feet and the light unto my path." When a black man has the word within him he will stand up with authority: "Persecuted but not forsaken, cast down but not destroyed."

When a black man has the word within him he will stand up with authority: "For I am persuaded that neither death nor life nor angels nor principalities nor powers nor things present nor things to come . . ." When the black man has the word within him he will stand up with authority: ". . . nor height nor death nor any other creature shall be able to separate us from the love of God which is in Christ Jesus our Lord."

When a black man has the word within him he will stand up with authority: "For you sometime were darkness and now ye are the light in the Lord; walk as children of light." When a black man has the word within him he will stand with authority: "Thy words were found and I ate them and thy words were unto me the joy and rejoicing of my heart, for I am called by your name, O Lord God of hosts." When a black man has the word within him he will stand with authority: "The blind will receive their sight. The lame will walk, the lepers are cleansed and the deaf hear, the dead are raised up and the poor have the gospel preached to them."

When a black man has the word within him he will stay on the path. When a black man has the word within him he will end up blessing other generations. When a black man has the word within him he will stand up with authority:

"The Lord is my shepherd, I shall not want. He maketh me to lie down in green pastures; he leadeth me beside the still waters. He restoreth my soul; he leadeth me in the path of righteousness for his name's sake. Yea, though I walk through the valley of the shadow of death, I will fear no evil, for thou art with me; thy rod and thy staff they comfort me. Thou preparest a table before me in the presence of mine enemies, thou anointest my head with oil; my cup runneth over. Surely goodness and mercy shall follow me all the days of my life and I will dwell in the house of the Lord forever."

QUESTIONS FOR REFLECTION

1. What is the significance of Eli's journey from the east to the west? Where is your journey taking you?

2. The one who possesses the "word" has courage, strength, authority, and knowledge. What does God's Word instill in you? How do you show this to the world? How does knowing God's "word" help you?

3. The focus in this sermon is on black men who have made a difference in the lives of others. Name some women who have had a similar impact on the world. What would it take to add your name to the list?

4. Hebrews 11 speaks of a faith that motivates persons to do things without scientific knowledge or proof. How does this apply to Eli? What are you doing by faith? What is your church doing by faith?

5. How does Eli make the journey as a person who is blind? How do you use obstacles to propel you along your journey?

NINE

THE GOSPEL ACCORDING TO AVATAR

Jesus Is Our Avatar

❀

SCRIPTURE: LUKE 4:16–21

I f you have your blueprints for salvation, the guide upon our journey, the rudder of our ship, the wind in our sail, the Bible, we kindly ask that you turn to the Gospel according to Luke. The Gospel of Luke, chapter 4. Moving to verse 16 in chapter 4 in Luke, I am reading from the New International Version.

> He went to Nazareth, where he had been brought up, and on the Sabbath day he went into the synagogue, as was his custom. And he stood up to read. The scroll of the prophet Isaiah was handed to him. Unrolling it, he found the place where it is written: "The spirit of the Lord is on me, because he has anointed me to proclaim good news to the poor. He has sent me to proclaim freedom for the prisoners and recovery of sight for the blind, to release the oppressed, to proclaim the year of the Lord's favor." Then he rolled up the scroll, gave it back to the attendant and sat down. The eyes of everyone in the syn-

agogue were fastened on him, and he began by saying to them, "Today this scripture is fulfilled in your hearing."

Beloved, a great theologian by the name of Howard Thurman in 1949 wrote the precursor to what we in the modern era call liberation theology or black theology. His book entitled *Jesus and the Disinherited* is the primer for all Christians who want to know what God says to those who have their backs against the wall. Years later, a brilliant scholar from Arkansas would become the first academic of authority on this idea of liberation theology. His name is James Cone. Cone has written numerous books, but I would suggest one in particular entitled *God of the Oppressed,* in which he encapsulates his thoughts and the goal of liberation theology. He merges the prophetic insight of Malcolm X with the radical, Southern-inspired theological discourse of Martin Luther King Jr. and Howard Thurman to produce a powerful academic perspective on the nature of theology. The fundamental theme of Cone's work, Thurman's writing, King's movement, and Malcolm's insight is that God is on the side of the oppressed. God is on the side of the vulnerable, broken, imprisoned, and poor.

It must be stated, however, that the real source of liberation is found in the Bible. From Genesis to Revelation, we witness a God who is concerned with the poor, the neglected, and the vulnerable. The embodiment, the incarnation of Jesus is the climactic cosmic event and statement of God's deep and profound love of humanity. The text that we are looking at today is one in which we could say that Jesus is giving what is called his inaugural sermon, the first time that Jesus preaches publicly. I like to say this sermon is the mission statement of Jesus. He is stating with clarity what he is called to do, how he is going to do it, and what, how, and with whom he is going to do it. He said, "I'm going to preach good news to the poor, proclaim freedom for the prisoner, bring sight to the blind, and set at liberty those who are oppressed." Here is Jesus, and, interestingly enough, he has grown up in an occupied colonized territory, for he is a Palestinian Jew. Some have a ten-

dency to forget that Jesus is a Jew growing up in the Roman world under the rule of Emperor Augustus, who had a hundred thousand troops at his disposal to send down to Palestine in case there was a rebellion.

Jesus grew up under this kind of oppression in a colonized community. He watched and witnessed as a child or he heard as a child that if you got out of line with the Romans, they would crucify you, and they did not crucify or lynch you in private. Crucifixion was a public event. The Romans would usually crucify someone on the most public road. As you were on your way to the synagogue, you could very well watch and witness somebody dying as you were going into service to talk about a living God.

At any moment, a Roman soldier could beat down your door, take your child or your spouse, and do whatever his sick, perverted mind desired with them. The reason Romans came into Palestine was not because they wanted to liberate Palestine or because they wanted to develop a relationship with Palestine. They came because they wanted to take the resources of Palestine. They recognized there were rich resources under the soil and that the people could also be a resource, to fuel their militaristic needs. The Roman soldiers and Rome itself went into Palestine because of a strange ideology. They believed they had "discovered" Palestine. Even though people were already living there, the Romans believed they had discovered Palestine. They believed that they were well within their rights to do whatever they needed to do to anybody because, after all, they were bringing civilization to Palestine. Because, of course, the Romans arrogantly considered themselves the most civilized people on the planet. Emperor Augustus (we have him to thank for the month of August, because he renamed the calendar so his name would appear there), Emperor Augustus reigned during what was called the "Pax Romana," or the "Roman peace," a time of relative tranquility for Roman citizens. But the price was an oppressive rule, and as Augustus expanded his empire he also pursued the idea that "all the world is Rome." Any world not con-

trolled by Rome was considered uncivilized, and Augustus succeeded in bringing Roman "civilization" to the Middle East, among other places. It became the duty of Rome to make sure that those who were uncivilized would understand how to live a Roman lifestyle.

When I looked at the development of Jesus as a child, and understood the life that he was leading, living, and experiencing, I could see that Jesus' life unfolded to a backdrop of Roman oppression. Several months ago, I took my son Elijah to see the movie *Avatar*. I thought I was going to see a nice sci-fi action movie. When I got in the movie, what I actually saw was a parable about liberation. Once I got in there, I realized that the movie *Avatar* was talking about colonialism and imperialism. This movie was a metaphor for how America operates with regard to foreign policy. Elijah saw something else. So there I was with my 3D glasses on, and folks around me were trying to figure out why this brother was being so loud, cheering on the Na'vi to take out the people who are trying to take over their planet.

For those of you who missed the film, let me give you the Otis Moss synopsis. The movie *Avatar* is simply about a corporation from earth that goes to another planet they thought they had "discovered," even though people lived there. A privatized corporation decides—because they think they discovered the planet—that they have rights to the planet even though there are blue people called "Na'vi" already living on the planet. The earthlings thought they were going to bring civilization to the planet but they were not concerned about the planet, they were concerned about what was underneath the soil, the natural resources. They wanted to send in troops to maintain and harvest the resources. Hmm. There was something underneath the soil and they wanted to send in troops to protect and collect this resource.

While there, they encountered the blue people called the Na'vi. In their arrogance, the earthlings thought if they built schools to teach the Na'vi how to act more like humans, then they would be able to trick the Na'vi out of their resources. Interestingly, it is alluded to very

quickly and slightly in the film that the Na'vi can't be bought. The earthlings said, "We don't know what these people want. We've built schools; they don't want that. We've given them medicine; they don't want that. We tried money; they don't know what that is. We don't understand; we don't understand what they want."

Finally, the earthlings prepare to conduct a preemptive strike on the Na'vi, to make sure the Na'vi will not be able to fight back. The earthlings are working to take the natural resources from the planet—in particular, a precious metal that is worth $20 million per kilo. In the film, we learn that the Na'vi are very wise people living in harmony with nature. They have no problem until this group from somewhere else shows up on their planet. All of a sudden, there's a problem when these people show up and say, we discovered this place and we need to relocate you to some reservations because we want what is underneath the soil.

In Na'vi culture there is an expression, "I see you," which doesn't mean that I physically see you, but I see your soul. I see who you really are. I understand that you are more than the label that the people around you have given you. I really see you.

When Jesus gives his inaugural sermon in the midst of the church, he is saying to all of Israel, I see you. I see your troubles and your trials and that your prayers have not gone unanswered. I see what you're going through. You are not the people that Rome says you are. I see you. We serve a God who sees our trouble, who sees us as we really are. The same God that sees the DNA in a cell, wrapped up in cytoplasm swimming in amino acids, is the same God who sees you. The same God who sees a hundred amino acids forming a single enzyme is the same God who sees you. The same God who created the heart with four distinct segments, a right and left atrium, and a right and left ventricle, with a right side that carries weak oxygen, and a left side that carries rich oxygen, is the same God who sees you. That same God created the sun that has rays powerful enough to boil the ocean, yet those same rays can cascade through your window and fall upon a sleeping

child and not wake the child. Our God has so much power that God is able to hold the physics of the universe in his right hand and deal with your prayers in the left hand. That God sees you. And I am so glad that God does not see us the way that other people see us.

The text is tailored to teach us simply this: God demands a holistic gospel. Most of our gospel, most of our preaching, most of what churches do today, is compartmentalized. We want something on Sunday and then we want to continue our mess Monday through Saturday. We don't want what happens in our relationship with God to interfere with our agenda. However, here Jesus is saying, I have a different type of gospel for you. For all of those who think it is wrong for you to engage in the world, I'm just going to give you a quote from Isaiah (61:1–2a): "The spirit of the Lord is on me, because he has anointed me to proclaim good news to the poor. He has sent me . . . to proclaim freedom for the prisoners and recovery of sight for the blind, to release the oppressed, to proclaim the year of the Lord's favor."

Now, Jesus has given his inaugural sermon; it's the first time Jesus preaches. He borrows a word from another preacher and then preaches for about fifteen seconds. Rarely will you find a preacher who will preach for fifteen seconds and then sit down, but Jesus packs so much into this small statement that, if you look at it the right way, it literally will blow your mind. He starts out with theology: "The spirit of the Lord is on me." That's theology. That's the anointing of God; God has consecrated me, set me apart to do a special work, and my authority does not derive from the emperor but my authority comes from my father. The spirit of my father is on me. Now, that's the theological part. Then he goes on to say he will "preach the good news to the poor." Now, that deals with economics because he's not talking about the spiritually poor, he's talking about people who are really poor and people who do not have enough to eat. But after he deals with the good news to the poor, he then says "freedom to the prisoner," which means that he's going to have a ministry of justice. And after the ministry of justice, he then says he's going to "bring sight to the blind," to have a

ministry that deals with health care. Now, after his ministry of health care, then he's got to deal with the oppressed, who are oppressed because of the political policies of the day. So Jesus' theology leads to economics, economics then leads into justice, his justice movement leads into health care, and health care leads into politics. He then ends once again in theology. He says, "This is the year of the Lord's favor." In other words, this is the year of jubilee. The year of jubilee, within the Hebraic tradition, is the year, after forty-nine years, of forgiveness where all debts are forgiven.

Now, I know many people here wish it were jubilee right now. If you want to see some folks shout, tell everybody in this place that all of their debts are forgiven. You have no more mortgage; you have no more note; your credit card bills have been paid.

Jesus was saying, I am the embodiment of jubilee; when I come into your life, your debts are forgiven. When I come into your life, everything people labeled you will be removed. When I come into your life, I will change your life to the point that people will not recognize you when they see you walking down the street. They will be accustomed to what they saw yesterday, but after I'm done with you today, you will have a different walk and you will have a different talk because I am the embodiment of jubilee. This is the demand of a holistic gospel, a holistic gospel that does not separate sacred from secular.

Now, within the Western tradition, we love a sacred and secular separation. That means what you do on Sunday has nothing to do with what you do on Monday. So you can praise God all you want and still own slaves. When you have a sacred and secular separation, you can kill and lynch on Monday and then talk about praising God from whom all blessings flow on Sunday, because there is a sacred and secular separation. It is about how you live your life from Monday through Saturday. That is when you merge your sacred and secular together.

The African and Native American traditions did not subscribe to this idea of the separation of sacred and secular. When one writer was trying to communicate with African people, trying to interview them,

he received a lesson pertaining to this lack of separation of the two. He asked an African, "When do you have your church service, when do you have your worship service?" The gentleman being interviewed replied, "Every day." The writer said, "What do you mean? Where's the building?" The African said, "You're in the building." The writer replied, "We're outside." The African said, "I know; the earth is the Lord's and the fullness thereof."

Wherever I go, I'm in worship because everything—wherever I place my foot—is something owned by God. The mere fact that I am in my body and in my right mind, because my body is my temple, means that I take the tabernacle wherever I go. As a matter of fact, when you have this perspective, you do not wait for Sunday to come for you to interact with God. You understand that, wherever you are, you are in the presence of God. Whether you are in church, out of church, at CVS down the street, in your car, at the club, yes, you are still in the presence of God because God is the owner and the creator of this world.

Jesus is attempting to teach this new theological idea. Now, what fascinates me within the black church is that worship brings something to bear in a very unique way. When we worship, our theology influences and changes our very psychology. Once you understand God is on your side—or you are on God's side—that's when you understand there is something bigger than you, and it changes the psychological dimensions of your mind. All of a sudden you realize you have been created by God. Knowing God took the time to create you, God took the time to design you, and God loves you—changes your self-esteem. You now walk differently because you have a relationship with God. Not only does it change your psychology when you have the right theology, but it also alters your sociology. Because your sociology is how you deal with other people, and when you know you are created in the image of God, and those people next to you are created in the image of God, then you have to engage someone differently than you would if you thought it was all about you. Even though some folk may be

acting a little demonic every once in a while, you understand they are still created in the image of God.

So your theology will change your psychology and alter your sociology. Once your sociology is altered, then you begin to shift and look at your ecology differently. Your ecology is simply how you see our place in the world. It is your understanding that the world was created by God and is God. It is not for us to have dominion over the world, to dominate, but instead we are stewards and trustees of the world, meaning that we can't just do whatever we want to do with this world because this is the only world God created for us. Our theology changes our psychology, which shifts our sociology and gives us a new ecology.

When we look again at the film *Avatar*, we notice the Na'vi have a different kind of theology from the people on earth. They see the world, Pandora, as being deeply connected to their God, Eywa.

They explained that even if one kills for food, one has to pray over the animal because killing is not something we desire. There is a scene where one of the characters literally prays over an animal, saying it is tragic any time one has to kill and Eywa must be asked for forgiveness. What got me in the film is when the people from earth, the privatized group (like Haliburton), came down on Pandora to get their resources with their privatized army (like Blackwater). They came there to take things out and they were going to bring these Avatars, people who are similar to the Na'vi but not quite Na'vi, to get the Na'vi to move to a private reservation so the earthlings could freely harvest the metal and the resources under the soil. A war broke out because the invaders destroyed the sacred tree. The tree held the Na'vi's history and culture, and the invaders tried to destroy the Na'vi culture and history by destroying this tree. In response, all of the people did something on their own. I know they look blue, but they are black folk because of what happens in the film when they reached a point where they did not know what to do. What did they do? They went down to the sacred tree and prayed to Eywa.

All of the Na'vi got together and they went down to the sacred tree and they started praying. They did not pray cute prayers like we pray—so that people will hear what we know and how big our vocabulary is. No, they had a Pentecostal moment. It was a Pentecostal prayer. This was Pentecostal praying in *Avatar*. All the people got together. They got down on their knees and then they started to move. They started to pray, and they said we want to hear from God because we need to know what we are to do.

I realized, at that particular moment, that if we are to transform our community with all that is happening, before we go out to decide we need to do X, Y, and Z, the community has to come together and we have to pray just like the Na'vi. I am not talking about those prayers we like to pray so that people know that we are wonderful, articulate pray-ers. The prayers that say, "Oh most auspicious God, you who are omnipresent, thank you, Oh Lord, for walking Timothy across the street." No, I am not talking about those cute prayers. I'm talking about the prayers that your grandmother prayed that came from her belly. I am talking about those prayers that said, "Lord, I need you right now in the life of my child. I need you to show up, show out in some form or fashion. I don't know what to do but I know you know what to do. I come before you with knee bowed, body bent, and asking you to cast my sins into the sea of forgetfulness. I need you to show up." You know, you survived on prayers like that, prayers that somebody prayed with authority and power. And if they had not prayed like that, you would not be where you are right now.

When I saw this in *Avatar*, I realized God sends a savior, and Jesus is our avatar. The main character in the movie was a gentleman by the name of Jake Sully, played by Sam Worthington. He was thirty-three when he played the character of Jake Sully. Thirty-three when he played the character of Jake—name begins with "J"—when he played the character of J. I wonder why they used that "J" name? I don't know, but in the movie, they take Jake's consciousness and they download it into another body. They take what's in him but they upload it—down-

load it, whatever—into an avatar, a body that's not like him. They take all that he has and they load it up into another body. He saves everybody in the film. He becomes the savior in the film. He's the savoir in the film but then he dies in the film. He's dead. I was sad, but three minutes later Jake comes back as a Na'vi. As a Na'vi he has part human DNA and part Na'vi DNA. The Na'vi called Jake part of the sky people, meaning you came from up there to down here.

I know somebody who came from somewhere, was downloaded into human flesh, so that you and I could be set free. He led a liberation movement. He set the oppressed free, he allowed the lame to walk, and they took him on Calvary and he died. He was dead on Friday, he was dead on Saturday, he was dead on Saturday night . . . but something happened after the midnight hour, on Sunday morning. On Sunday morning, Jesus got up with all power in his hands. I don't know about you, but I'm glad Jesus is my avatar. He's been downloaded into my life, downloaded into my heart. Has Jesus downloaded his love into your spirit, his power into your life? Jesus is our avatar. He's downloaded into a human body. He looks human but he's not exactly. He can do everything a human can do, but more. He's downloaded into our lives—and he dies, but then he's resurrected.

God is simply saying to us as a community that God sees us. I mean, God really *sees* you. It's not about what other people see; God sees you. That's why you need to stop answering to names that God did not intend for you to answer to. God sees you and God is calling the church to have a holistic gospel. I know folk want to praise him, praise him, praise him, but you need to add your praise and your protest together and your worship and your work and your sanctified self with your service. It all should move together holistically. To do this, we must simply understand that Jesus is our avatar.

And as I mentioned, when the Na'vi were praying at their sacred spot and the sacred tree, what James Cameron probably didn't realize is that he was borrowing something out of African and African American culture. When they were all praying together and swaying

together and speaking together, I realized what they were doing is something that has been a part of what is called Gullah culture.

Gullah culture comes from South Carolina and from Georgia, the Sea Islands, or what they call the barrier islands, where groups of Africans lived without much connection to European civilization. They built their own culture and their own language, and most of their language is a combination of African languages, usually from Sierra Leone, and bits and pieces of German and English. Their worship style is very deeply and closely connected to the worship style of people from Sierra Leone. They do something that is a dying art in many areas; it's something called the ring shout. The ring shout took place when people would get together, form into a circle, and begin to move, sometimes counter-clockwise or sometimes clockwise. As they moved, they would utter prayers unto God. Sometimes a spirit would overtake people in the circle and they would begin to shout and to testify. They would say after they finished that particular moment that they literally heard God speaking to them in a clear voice.

That moment in the film when the Na'vi did the ring shout, all of the Na'vi came together, the young and the old, the elders and those who were just born into the world, and they started praying together. They recognized that if they were going to protect and keep their planet from being destroyed by this colonizing force, it was prayer that would bring them together and allow them to do so. That African ring shout has been passed down from generation to generation, and that is still to this day practiced on those barrier islands off the coast of South Carolina and Georgia. The people would come together, put their arms around each other, and they would begin to sway. As they looked up at the cross, they began to pray.

I invite you to pray with me as we focus our eyes on the cross. Whatever God is doing in your life, whatever you need in your life, offer that prayer, right now. God has already blessed us and pulled us through so many dangers, toils, and snares. We thank you, Lord, We thank you for your mercy. We thank you for your love. We thank you

for pulling us out of fires and ditches and dungeons. We thank you for closing doors that should not ever have been open in the first place. We thank you for adding and subtracting in our lives, adding people who know how to pray and subtracting people who don't know you. We thank you for how you have blessed our children and blessed our families, and when we look back over our lives and see all that you have done for us our souls well up and we just simply have to utter thanks unto you. We give you thanks today; we thank you for yesterday and for today, and we thank you for what you are going to do in our lives.

May the spirit of our God rest in your household; may God place a hedge of protection around you and yours. May no demonic force enter your house. May God push out any negative force that seeks to destroy you. May the spirit of God rest, rule, and abide in your life and may the road rise to meet you. May the wind always be at your back, may the sunlight of Jesus Christ always grace your cheek, and may rain gently fall upon your fields. Until we meet again, go in peace.

QUESTIONS FOR REFLECTION

1. Luke 4 highlights Jesus' inaugural address where he states his mission. What is your mission statement?

2. Jesus' mission and ministry are shaped by the subjugation of his people by Roman power and domination. What factors have shaped your worldview and philosophy of life?

3. In what areas of your life do you seek God's Jubilee? Where is God's Jubilee needed in your community and in the world?

4. What are some elements of your theology? How do they relate to your psychology, your sociology, and your ecology?

5. Describe what it means to claim Jesus as your Avatar. What should it mean for the church to claim Jesus as its Avatar?

TEN

THE GOSPEL ACCORDING TO FLIGHT

Prophetic Purification

✿

SCRIPTURE: MALACHI 3:1–4

If you have your blueprints for salvation, the guide upon our journey, I would kindly ask that you turn to the last book in the Old Testament, the book of Malachi, chapter 3. I'm going to read from the New Revised Standard Version, beginning with verse 1:

> See, I am sending my messenger to prepare the way before me, and the Lord whom you seek will suddenly come to his temple. The messenger of the covenant in whom you delight, indeed he is coming, says the LORD of hosts. But who can endure the day of his coming, and who can stand when he appears?
>
> For he is like a refiner's fire and like fuller's soap; he will sit as a refiner and purifier of silver, and he will purify the descendants of Levi and refine them like gold and silver, until they present offerings to the LORD in righteousness. Then the offering of Judah and Jerusalem will be pleasing to the LORD as in the days of old and as in former years.

Beloved, I'd like for us to focus on the subject of prophetic purification. There is a film starring one of the greatest actors of this or any generation. The film is entitled *Flight*. And it stars a gentleman by the name of Denzel Washington. The film was directed by a protégé of Steven Spielberg by the name of Robert Zemeckis. It is a powerful and painful story drawn from a very gifted but flawed pilot by the name of Whip Whitaker. Whip is charming, charismatic, and aeronautically brilliant but is cursed by the spirit of addiction. He is a high functioning alcoholic. Whip's smile and charisma allow him to charm his way through almost any crisis. He is gifted, yet addicted. He is blessed, yet broken. He is powerful, yet bathes in the profane waters of human indulgence. And anyone who has seen the movie will agree that Denzel's performance is masterful.

We are forced to witness the life of a man crushed and saved by unknown forces. It is after a miraculous and mysterious airplane crash, one in which Whip is pulled from the burning wreckage. This gifted pilot goes on a journey where he is forced to confront his demons and his addiction. He is pulled out of an aircraft fire broken and beaten and placed on the path of purification and detoxification. The only way Whip will overcome his demons and confront his addiction is through purification.

Purification is the process of preparing the spirit to enter a holy place by separating the mind from destructive thoughts. Detoxification is the act of removing toxins from the body or toxic people from your life.

Addiction is caused when foreign substances enter the body, stimulating neurons in the brain and altering the neural pathways of the brain. The addict's neurons send a signal to what is called the reward center of the brain, the area of the brain that stores chemicals connected to memory. These neurons pass information to this part of the brain. The reward center tells neurons in the reward center to store memories about the drug that was just taken. The memories are coded by a chemical called dopamine. Dopamine is released in your brain when a good experience or a good memory triggers that release.

God ordered dopamine in our bodies for survival so that we would eat and reproduce, because there are good memories associated with certain things that contribute to our survival. For example, I can release some dopamine in your brains, right now. All I have to do is to tell you to remember the best sweet potato pie you have ever had in your life, and all of a sudden neurons are fired in your brain that go to the reward center and cause dopamine to be released in your system.

I didn't show you a piece of pie. I didn't have you taste a piece of pie, but the memory coded chemically in your brain brought you back to the moment when you had that taste of pie. You even know how the kitchen smelled when the pie came out of the oven because that memory is coded with dopamine. The addict alters this simple process by forcing an overproduction of dopamine, and the body deeply craves this chemical. It's not the cocaine the addict really craves, but the dopamine that is released in the brain, which caused the addition.

I can release some more dopamine if I say the words "Denzel Washington" and "Idris Elba."

Half of you just sinned as a result of your reward center and dopamine moving in your brain. Now, for the brothers, if I say "Halle Berry" or "Kerry Washington," all of the sudden the mind's focus is on the reward center and dopamine has been released in your situation. Interestingly enough, the only action that can release dopamine in your brain the same way as when one is high is as a result of food, laughter, music, working out, worship, or love. The only way to rid the addict of his or her addiction is through what is called purification. Purification cannot be done alone, but must be done in partnership with somebody of authority. The addict must admit he or she is an addict and a foreign substance has taken control of the rational and spiritual parts of the body, mind, and spirit.

The word of God says, "I'm sending a messenger to you ahead of me to make a way for me." My translation is, "I'm sending a messenger, a sponsor, whose sole job is prophetic purification." The people of Israel are not unlike Whip Whitaker. Charming, charismatic, yet

addicted to self-serving worship where God has been replaced by ego and materialism. The only way that people will encounter God is through a process of purification. There's a two-step program for purification. Not twelve steps, but two steps.

There are two things that you must do if you want to enter into a moment of purification. The first step to recovery is to admit that you are addicted and your life is unmanageable. Without this admission there is not redemption. Second, you've got to turn your life over to God and ask God to do an intervention. The people of Israel were being confronted by prophetic intervention. The Levites, the priestly cast, had failed Yahweh. Those called to speak up with authority on behalf of the poor, those credited with the task to cover the widows and to speak truth to power had failed God. In this passage, God is preparing to send a messenger unlike any other messenger in history. God is breaking into history and recreating the spiritual neural pathways of human history. Just as it is during Advent, when we celebrate God breaking into history, recreating, and doing an intervention in our lives, the birth of Jesus is an intervention into human history.

Some of you are saying, "This is fine, preacher; I appreciate you breaking that down. That's nice and that's cute, but it doesn't seem to connect with me."

However, if we glance at history with judgmental eyes, we escape the indictment of Malachi and go home with a false sense of superiority. The real culprit in the text and the real culprit theologically is the church. The church is like Whip Whitaker. The church has become an addict. We have become the greatest high-functioning junkies—able to fool everyone but God. We act sober when we are high as a kite. Foreign substances have been introduced into the body of Christ. We are so addicted to certain drugs and substances that we fail to even realize we are high most of the time. The enemy is steadily pedaling spiritual addictions. Insecurity and fear have overwhelmed us and the church will take anything to hide her frailties. We'll smoke some gossip, freebase some anger, shoot up with half-truth, drink a

fifth of chaos, start tweeking on hypocrisy, and pedal dime bags of "everyone is going to hell but me" theology.

The church is high as a crack addict on the fifteenth and thirtieth of the month. It is Charles Kimble who says when religion becomes evil two things are present. I give a remix the way Pastor Emeritus Dr. Wright said it, "When you find religion that has a perspective of 'ain't nobody right but us,' you are headed down a path of being addicted." When a religion declares a holy war on somebody else as if it is so holy and so perfect, you are headed down a path of addiction. I'm here to let you know that there are some high churches running around here. The church is high. You have a high church anytime you condemn people who are gay but forgive everybody who sleeps around with Loddy Doddy and everybody else. It's a high church that fights for abortion but won't fight for children after they're born. It's a high church that will fight for a nativity scene in a public square but will not fight to end the war on drugs and for all of the five hundred thousand drug addicts who are incarcerated. That's a high church.

A high church will fight for prayer in school but will not fight for equal funding for the school. A high church will argue over speaking in tongues but has no energy to speak truth to power. A high church is all of these things, but don't just point your finger at other churches. We got some spiritual addicts in Trinity, too. We have some addicts in Trinity who will get high on a lie. You'll smoke an entire dime bag of gossip, then wash it down with a fifth of half-truth. A high church.

I'm talking about "I heard, I heard, I heard"—stop smoking that stuff. What you need to know is that the Lord is the one who is our shepherd. The Lord is the one who directs our paths. You need to put down your spiritual crack pipe and open up your mouth and give God the praise.

I'm just going to give you two instructions about how to detox. But let me tell you, if you want to detox, if you want to have prophetic purification, there are two things—the text is very clear—there are two things that you have to do.

The one thing is that when this messenger comes, the messenger will come like the refiner's fire. The refiner's fire. That doesn't make sense to most of us because we are in a modern age, but the refiner's fire is connected directly to blacksmiths. The blacksmith's job was to reshape metal. In order to reshape metal, the blacksmith had to take metal in its raw form, iron, and put it in a furnace. The iron had to be hot enough so that it would lose its form.

In other words, after the blacksmith is done and because the heat has been so high, the metal can no longer be the same way that it was when it went in. The blacksmith's job is to make metal into a tool so that it can be utilized for the building of the entire community.

Many people think that when a blacksmith uses metal, the metal is already pure. But there is no such thing as pure iron. Iron is always intimately connected to carbon. No matter what you do, if you find iron ore, it has other elements in it. And if the iron ore could talk, it would assume that "I always have to stay intimately connected to the stuff that I've been intimately connected to." However, when you go in the refiner's fire, the heat is so hot that what was supposed to stay connected to you can no longer stay connected to you. It has to separate from you because it can't handle the heat in the furnace. You find out that you have more strength once you've been disconnected from the impurities in your life. Before you went in the fire you thought you needed the carbon in your life to survive, but once you go into the fire, you realize that the heat will separate you from those elements from which you thought you could not be separated. However, beforehand, the elements were telling you, don't go into the fire, because if you go into the fire then we might break up. And, so, if the iron could talk, it would say, "Don't take me into the fire."

But the blacksmith knows better than the iron, because the blacksmith already has in his imagination what the iron ore is going to become.

There are some people whom you thought you had to stay connected to in order to survive, but God put you through a furnace, and

those people left you in the midst of your fiery experience. Yet when you came out, you looked better than when you went in. Now they are trying to get with you after you've been through the fire. But here is the thing: they cannot connect to you anymore because of what you have been through; they just won't stick. There are some people trying to reconnect to you, but you've already been through the refiner's fire and God has made you into something new.

So once you come out of the fire and God has fashioned a sword, then here comes some carbon saying, "Hey, remember those times we used to hang out?" But you say, "That was when I was iron ore, baby. I'm a sword now. I look good and if you put me in the hands of the right swordsman, I can save you or I can cut you. One or the other."

I've been made into something new. So refiner's fire is a way to detox, but there's another thing. The other thing is simply this— fuller's soap. I can get that anywhere, you say. No, this is *fuller's* soap. One must understand, when Malachi speaks of fuller's soap, he is actually speaking of a region of Jerusalem where fullers—people who fashioned and took wool from sheep and created garments out of it— lived. Fulling is a process of cleansing wool.

Now, the Roman way of cleansing wool was very different from the Hebraic way. Romans—I'm not making this up—Romans would clean wool by using something very acidic. And what they would use was their own urine and mud mixed together. It would get out some of the dirt but would leave a lingering smell. So one always knew that you had purchased that sweater from Rome because there was a lingering smell. The Hebraic community figured out how to bring out all of the impurities but not have the smell.

This is amazing. The fuller community in Jerusalem would do this: They would shear the sheep in order to get the wool, which was caught in strands and which had picked up dirt and bacteria. In order for them to clean the wool, they had to wet it. And they would take the soap made from animal fat and put it on the wet wool. They would then get the dirt out of the wool by beating it on a rock.

Now, the wool is probably upset that it is being beat, but, you see, the fullers knew that the beating process was getting stuff out of the wool that shouldn't be there in the first place. So the wool would be beat over and over again. After the beating process, the fullers would then stretch the wool, because once you stretch the wool, you also increase the strength of the wool—it's been beat and it's been stretched—now the wool has more strength than it believed that it could have. It's been wet and it's been washed and now the wool is releasing the toxins that would be destructive to the wool over time.

Now, here is the thing that makes me shout. The Hebrews knew they could not get rid of all the toxins, so they had to call in the big guns. What they do to release all of the toxins was to leave the wool out in the sun, because the sun can do more than any man can do. The sun can take some things out that nobody else can take out. The fullers leave the wool in the sun and the ultraviolet rays of the sun get in between the fibers and destroy the bacteria, because the sun can remove some things that no one else can remove.

The sun can remove some things. I'm not talking about the S-U-N; I'm talking about the S-O-N. And I don't know about you, but I know my God can remove some things that nobody else can remove. And because God shows up in my life, God removes.

So there are two ways to detox: There's refiner's fire and there's fuller's soap. You have to leave it in the sun and that's why Grandma used to hang things out in the sun. Grandma knew you get whatever dryer you want to get, but there is nothing like the sun for taking out some impurities. Because the dryer doesn't have purifying power.

Let me give you the last text in our scripture passage. Verse 4 says that once the people are refined and purified, then they will bring an offering unto God. Then Judah and Jerusalem will bring an offering unto God. After the purification, after the refining fire, after the fuller's soap, then Judah will bring an offering to God. To fully understand what I am saying, you need to know the direct English translation of Judah. Judah means "praise." In other words, after people have been through

the fire, after they've been beaten, after they've been stretched, and after the Son has taken out the impurities, then praise comes to God.

Sometimes you need to give God a praise offering. An offering for what God has done in your life. Some of you know about addiction. If you have ever been through addiction, if God's ever brought you through, there's a level of praise you do that other people refuse to do because you still have in your memory what you used to be. But when you look and see what God has done in your life, the only thing you can do is give a praise offering.

I will bless the Lord at all times. God's praise shall continually be in my mouth. Give a praise offering. Do you remember what God has done for you? Your purification was your worst memory, but it was your best experience because you went through the fire. You went through the beating, but look at you now. You've been separated from people who tried to destroy you. You've been separated from your addiction and now you're serving as a deacon or you're up in the choir loft; but you remember what you used to be. And every once in a while you can praise God all by yourself because when you think of what the Lord has done for you something wells up in your spirit.

You thought God was trying to hurt you. You thought God was trying to destroy you, but God said just let me work my work. When you come out, you'll be separated from elements that tried to get you high. You'll be separated from elements that tried to destroy your life. You'll be separated from elements that took you down the wrong road. When you come out, you'll be like pure gold. When you come out, you'll be like pure silver. When you come out, you'll be a new tool. You will be something new. You know what you used to be. You'd cuss anybody out. You'd be ready to get in a fight, but now you're ready to pray. That's God working in your life.

After you have been through a detox, you are stronger than you were before, because stuff that used to tempt you doesn't tempt you anymore. You now have a sponsor you can call on. When you feel that you're moving in a wrong direction, you call up your sponsor. Jesus is on the main

line. Tell him what you want. We have a sponsor. And our sponsor has a three-step program. There are two steps for detox but God offers a three-step program: the Father, the Son, and the Holy Ghost.

It means that God covers you wherever you're going. Shaka Zulu found out that one of the best ways to engage British soldiers is with a three-pointed attack. You have someone as the point, two people on the sides, and you build what is called the wedge. The wedge is also used in football by special teams because the wedge can move in any direction and constantly protect the person with the ball. And when the Father, the Son, and the Holy Spirit have me, in whatever direction I turn, I have protection all around me.

You ask, "Well what about the back?"

Don't worry about your back because grace and mercy have you covered. So the next time someone tries to get you high with a spiritual crack pipe of gossip, just call on your sponsor, Jesus.

God is calling us to purification.

QUESTIONS FOR REFLECTION

1. The preacher states that "purification is the process of preparing the spirit to enter a holy place by separating the mind from destructive thoughts." How do you prepare yourself for prayer? For worship? For community in the church?

2. What in your life needs God's intervention? What hinders your surrender to God and God's will?

3. In what ways does Whip Whitaker undergo a transformation? What is the role of redemption in his story?

4. What is the difference between the "refiner's fire" and the "fuller's soap"? How do they each serve to purify and detox? How do these principles apply to your life?

5. What are the elements of transformation that the film highlights? How can these elements be applied to congregational life?

ELEVEN

THE GOSPEL ACCORDING TO THE BUTLER

Everyone Needs a Butler Spirit

❀

SCRIPTURE: JUDGES 7:9–12

I f you have your blueprints for salvation, the guide upon our journey, the rudder of our ship, I'm going to kindly ask that you turn with me to Judges chapter 7, beginning with verse 9. I read from two different translations, the New Revised Standard Version and the OM3 translation. The NRSV translation reads this way, beginning with verse 9:

> That same night, the LORD said to him, "Get up, attack the camp; for I have given it in to your hand. But if you fear to attack, go down to the camp with your butler Purah; and you shall hear what they say, and afterwards your hands shall be strengthened to attack the camp." Then he went down with his servant Purah [the one who is called "butler"] to the outposts of the armed men that were in the camp. The Midianites and the Amalekites and all the people to the East lay along

the valley as thick as locusts; and their camels were without number, countless as the sand on the seashore.

Beloved, is it not interesting that people who never contributed to the cause of liberation have major opinions about those who did or those who did not? If you want to find those out-of-work professors, one of the best places to find people who are out of work and are professors is usually at the barbershop and the beauty salon. They are self-appointed, adjunct professors of everything, who philosophize on anything.

I heard a gentleman at one of these establishments not too long ago make the statement, "I'm too radical to have been a part of the movement. I would have hit somebody if I had been down South. They'd have had to kill me. If someone took a whip to me I would just be a dead slave." Then he went on to say that he was with Malcolm. I piped up and said, "No you weren't. You never faced a mob; you never worked with Malcolm, you never organized with Huey P. Newton, you never marched with King. You simply stood on a corner saying things about everybody else because you were not participating." Inevitably, these barbershop conversations move to criticizing the people whom the professors feel were not radical enough.

They use this term, this ugly term, in reference to the people they feel were not radical enough. They say that they were "Uncle Toms"— talking about people who did honest work, who got up early in the morning and went to bed late at night. The people whom August Wilson wrote about in his plays *Two Trains Running* and *Fences*—people who somehow allowed our forward momentum. Let me see if I can set the record straight. There are many unsung heroes in our community who had to shine shoes, had to scrub floors, had to be called boy, and girl, and every other ugly word you could think of to make a way for us today. So never get it in your spirit that you are somehow revolutionary or radical, because many of us did not have to deal with the stuff our ancestors had to deal with.

My name is Otis Moss III. I mean, I was named after my father, who is Otis Moss Jr., and he was named after his father. We are the products of Otis and Magnolia Moss, my grandparents, who were sharecroppers in the western portion of Georgia. My grandfather raised five children by himself after his wife died, and then, due to an unfortunate car accident, left my father and his four siblings to face grief all alone. There is nothing Uncle Tom-ish about getting up early, about trying to make a life better for your children. There is nothing Uncle Tom-ish about having to work from sunup to sundown. You may not have a degree in your back pocket, and many of these people were not looking to get some bling, but were just looking for a better life for their families.

No one should look down upon those unsung heroes in our community who worked so very hard to make a life and set things on a better course for another generation. And that is why the film *The Butler*—based on the life of a gentleman named Eugene Allen, who worked as a butler for more than three decades in the White House—is the story of an unsung hero. The film is the somewhat fictionalized story of Allen's service at the White House through the tumultuous civil rights decades, through the tenures of several presidents.

The butler in the film is named Cecil Gaines, played by Forest Whitaker. What is so powerful about this story is that Mr. Gaines stood with dignity for decade after decade, being the best that he could be in a system that devalued black intelligence and honest work. What inspired me in the film and what is so inspirational about Cecil Gaines is that his sole, singular purpose was to make life better for his family.

He desired to make a better life for his wife, Gloria, played wonderfully by Oprah Winfrey, and his sons Louis and Elijah, who were the catalysts for his work ethic. While I was watching the film, some scripture was illuminated for me. It brought to mind this particular warrior in our scripture text by the name of Gideon. Gideon had been called by God; he had a special purpose to be a warrior and a leader.

He had great gifts, but he would only become great if he was connected to a small silent man by the name of Purah. Purah was the attendant, the armor bearer of Gideon. He was the butler, you could say, trained in the martial arts. Purah was an expert marksman, a swordsman who could also throw the javelin and spear and who had mastered hand-to-hand combat.

The servant was trained to assist and spar with Gideon. That is what the role of this servant was to the leader in Israel—to make sure that his master's swords were in place, to carry the armor, and to inspect everything. His job was simply to make Gideon shine. Purah's job, and he recognized it as such, was to make Gideon look good. Purah understood it this way: "I've been given this gift that when you do well, I do well. So I'm going to do whatever it takes to make you look good and for you to be at your best level." Scriptures state that he is a servant. This may seem like a lowly position to many, but the servant's job, the butler's job, the armor bearer's job was to make Gideon shine. To prepare him for battle, relieve him of certain duties, to do the work at which he was gifted.

We need people with a butler spirit, a Purah spirit. Purah was viewed by God, and by Gideon, as a valuable person. God states to Gideon, "I have given you victory over your enemies but if you are afraid and you're not sure about what I said, then you need to take somebody with you who has a relationship with me who can remind you that I have already given you the victory." What is it about this servant, this butler, that empowers the warrior Gideon? I think we need to search a little bit deeper to learn some of the characteristics of this butler spirit.

What I love about Purah and what we must learn from Purah— who is a servant, who is an armor bearer, who is one who has been trained in the martial arts, whose job is to make Gideon look good— is that he lives from acceptance, not for acceptance. This is his characteristic. He says, "I am satisfied with the position that I have been given because I know that I am gifted at the position that I've been

given." To be a servant, you must be secure in who you are. Purah was not trying to be anybody else. He was not trying to stab Gideon in the back. He was secure in his relationship with God and with his relationship with himself. He recognized that he was an armor bearer, he was a servant, and that he'd been given a very special assignment to make Gideon great.

"You won't hear me speaking in scripture," Purah might state. "I am just in the background speaking in the ear of Gideon. I will not be on the television. I will not be on a reality TV show. You will not find me anywhere trying to get noticed. All I'm going to do is try to make the person I have been assigned to better than that person is right now. I'm not looking for approval. I do not care if you don't like the fact that I'm a butler. I know God gave me the assignment. And since I know that God told me to stand with Gideon, I'm going to do the job the best that I can. I am a butler and I'm proud of it. I wear my uniform with pride. As a matter of fact I wear a crisp, clean shirt," just like the late Lieutenant Arlington Swan did every Sunday here at Trinity, and every day of the week. He was the kind of butler who would welcome you into the church, not keep you out, as many security professionals want to do. He wanted to bring other people in.*

When you are not looking for acceptance and you know who you are and you know that God has given you an assignment, you are not looking to be like anybody else. Because you know you are the best "you" that you can be. God has assigned many people an assignment.

* This sermon was preached a week after the death of one of our beloved elders, Lt. Arlington Swan, who served as head of security at Trinity United Church of Christ for decades. He always arrived early in the morning wearing a crisp, clean white shirt. He believed it was his calling from God not only to protect the church, but to make sure everyone who walked through the doors was treated like royalty. His warm smile was infectious and his memory of the youth and youth workers impeccable. Lt. Swan not only served as a security officer but loved to sing praises to God and was unafraid to share his love of God with anyone.

Your assignment may not be up in lights. Your assignment may not be written down in history. However, you will end up blessing other people. I want to stop here, parenthetically, to say that I am so glad that those of us who have gathered in this place had a Purah in our lives. I know that some of you are trying to act all holy on me today, but if some of us hadn't had a Purah in our lives, we would have never achieved what we've achieved.

There was somebody who had an assignment to make you better. There was somebody who had an assignment to put a roof over your head. There was somebody who had an assignment to put clothes on your back. Your Purahs may have only had a third-grade education; they may not have known anything about philosophy or theology, but they knew that God was good all the time. And they could quote some scripture, and they put it into your spirit. The reason that you have a little extra power in your step is because there was a Purah in your life who simply told you that you could do what God had all ready destined you to do. You can sit on your hands if you want to because I'm just talking to those people who had a Purah in your life.

Your Purahs will not be on the front page of the paper. They will not be in *Ebony* magazine. They will not be in *Essence*. You will not hear them on BET. But I'm here to let you know that if they had not been in your life, you would have been in some gutter. You would have messed up your life. You would be incarcerated right now. You would have gone crazy. But you had a butler who said, "I'm going to make sure that you live up to your potential." Your Purahs were not looking for acceptance. They were not looking for somebody to say that they were okay. What I love about the film *The Butler*, what I love about Purah, is that in so many ways these two are connected.

As you will notice in the film, Cecil Gaines took great pride in everything he did. When he was shining shoes, he wasn't just shining shoes. He knew that the shoes were reflective of him—when he shined them it was reflective of his work. He wasn't going to halfway do anything, because it was reflective of him. He knew that he had a rela-

tionship with God and that relationship was reflective of all the work that he did. The other characteristic of Purah and the other characteristic of this aspect of servant leadership is that you bring value to your work. My work does not simply bring me value, I bring value to my work. I have pride in my work.

It reflects who I am. My soul is wrapped up in my work. I work hard because of my relationship with God, who is wrapped in my work. Purah had been training for his assignment all of his life. You must understand that, in the Hebraic tradition, you trained all your life to be a servant of a judge or a king. That was the position that you wanted. You were to walk behind that person, give him the right sword or javelin. You were to encourage that person. However, here is the thing that you may not know about the ancient tradition. I did the research in order to understand what these armor bearers did. When the master went into battle, and when he fought and injured someone, that person fell to the side. And it was the job of the armor bearer to finish the job.

If Gideon injured someone and then had to go fight someone else, just so the injured person wouldn't be able to get back up and cut Gideon from behind, it was Purah, the armor bearer, who had to take care of the injured man who was now behind so that Gideon didn't get stabbed in the back. All of the armor works for the front. There is no armor on the back. So you need somebody who's got your back when you go into battle. Therefore, Purah would go with Gideon, and he would walk behind him in case somebody tried to sneak up behind him. In other words, I will let somebody take me out before they take you out.

Purah had the kind of spirit to simply say, "I take so much pride in what I do that I'm going to do whatever it takes." And that's what I loved about Cecil Gaines in the movie. Cecil Gaines was the best butler that the White House ever had. He didn't just do things halfway, he did them the best that he could because he took pride in everything that he did. He was not trying to be rich. He was not trying to buy bling. He was not like the preachers from Los Angeles, no. All

he was trying to do was be the best that he could. And if I may stop here parenthetically, because I know some folks have been watching a certain reality TV show that does not show the best of the church. I'm here to let you know that the greatest preachers were not on TV. The greatest preachers never preached in L.A. Howard Thurman could not fit more than 250 people in his church, but his message went around the world. Samuel DeWitt Proctor, who worked part-time all throughout his life, had to hold down two jobs just to pay bills. Vernon Johns after leaving Dexter Avenue never went back to pastoring again, but he influenced so many other people. Marion Stewart, who was one of the first political writers and also a preacher, influenced women down through the centuries. Ella Mitchell never had a megachurch, but Ella Mitchell influenced many women in ministry.

There are so many who had to work other jobs, yet they took pride in what they did. You bring value to your work when you have a butler spirit. Here is the other thing that I like about Purah. It is a very simple thing, this one characteristic. First, as we stated, he's not looking for acceptance. Then, his second characteristic is that he brings value to his work. However, there is a third characteristic—he is willing to stand in the shadows. "I will stand in the shadows so the light comes down on you. I don't need to be at the press conference. I don't need to be on television. I just need to do the organizing in the back." God has given Purah this particular gift. Purah is only mentioned twice and his assignment is simply to encourage and prepare Gideon.

We see in the text that Gideon is told in chapter 6 that God is going to give him victory. God says, "I've given you the Midianites. I've given you the enemies. You do not have to worry about anything." But watch what happens. God says to Gideon, "You need to go down into the enemy's camp, just peer over on the edge and listen to what the enemy says about you. That's a whole other message. You need to hear what the enemy says about you. The enemy talks about you because the enemy already knows how powerful you are. If you are afraid to go down there, I want you to bring Purah with you because

Purah is your armor bearer, your butler, and go hear what the enemy is saying."

In order for you to be a butler, to work with a judge, you have to know Yaweh yourself. In my sanctified imagination, I can imagine Purah walking with Gideon, just walking one step behind, and, as Gideon is getting nervous, Purah is saying, "Don't you remember God said he'll never leave you nor forsake you? So be of good courage and keep on marching. Don't you know that no weapon formed against you shall prosper? So keep on marching. You need to know that the Lord is your light and your salvation. You need not fear. So keep on marching." You sometimes need somebody in your ear when you're stepping into enemy territory; you need someone to remind you that God has all ready put certain things in your hands.

You need somebody with a Purah spirit, a butler spirit, who will remind you that everything is going to be alright. Have you had somebody in your life who was willing to encourage you when you couldn't even encourage yourself, who would remind you that God is with you even though everybody else stepped out of your life? I'm so glad God will provide a Purah in your life, a butler in your life to encourage you when you need it. So we see in this text that other characteristic of this particular butler spirit, a principle that we must understand. When you learn how to serve in the shadows, sometimes God will put the spotlight on you.

If you learn how to serve when the lights are off and nobody knows what you're doing, when you are still operating with integrity in the darkness, then God will turn on a light so that other people can see your work. Part of the problem is that we live in a spotlight generation. Everybody wants to be the star of every particular show. But you have to learn how to serve in the shadows, when nobody else knows what you're doing, but you keep on serving God anyhow. If the reason that you serve is for recognition, then you don't need to be serving God. However, if you are serving God so you can glorify God and God's realm, then God will reward your service.

Every once in a while, God will elevate you, and so if God gives you shoes to shine, then shine those like no one can shine shoes. Shine your shoes so well that the angels in heaven will bend down and ask can you hook a brother up. Press shirts so well that even those spirits of people who are dead will come back from the dead and ask can you hook me up? If you got to braid hair, braid hair like nobody else can braid some hair. Be the best that you can at what you do, because nobody can be who you are. God sometimes just calls you to be the best that you can be. You must serve in the shadows, and if you serve long enough in the shadows, sometimes God will turn on the spotlight.

Do you know there are some other butlers in the Bible? There's a butler by the name of Joseph. Joseph was placed in a dungeon, and Joseph eventually became the butler for the second in command in Egypt. Do you know about the butler by the name of Saul? Before Saul became king, he had to chase around donkeys, in other words, he had to serve someone else, be a butler. David, before he even fought Goliath, had to learn how to serve his brothers. You got to do some stuff in private before God can elevate you for some things in public. Stop trying to get public praise when you have not yet learned how to praise God in private. You need to do some things when other people cannot see you.

Here is the final characteristic of the butler spirit that, if you want this spirit, will change your life: My joy flows from witnessing the success of others. I am not looking for my own blessing. I get a blessing every time you get blessed. When you watch the movie *The Butler*, you will see that it's about a father and his son. Essentially, that's what the movie is about.

It is about Cecil Gaines and his older son. His older son goes to Fisk University and has the nerve to come home and call his daddy an Uncle Tom. He didn't like what his dad was doing, being a butler at a time when the civil rights movement was changing this country. He didn't like what his daddy was doing. Now, you got to understand the

absolute boldness, tenacity, and foolishness of a black son saying this to a black daddy; that's a whole other story. Now, here is the thing. It was his daddy who paid for him to go to Fisk University. It was his daddy's work in the White House, serving folk who disrespected him, that allowed this son to have an education.

Do not ever disrespect somebody who gets up early in the morning to make life better for you. Do not you ever disrespect somebody who's been working hard so that you can have a better life. How dare you disrespect our ancestors? They dealt with stuff you don't have to deal with today. He had the nerve to get upset, and here's the other killer thing. This is crazy. Even after the son disrespected the daddy, the daddy kept blessing the son with tuition. The father said, "I won't talk to you, but I'm still going to supply your needs. You may not hear my voice but I'm still going to supply your needs." Have you ever had a fight with the Father? You can't hear the Father's voice, but the Father is still supplying.

There is one more thing in the movie that messed me up spiritually, that's connected with Purah. There's a statement in the movie (and I paraphrase). They tell Cecil Gaines that when you're a butler, when you come into a room, you should be invisible in that room. Those you are serving should not know that you are in the room. When I first saw it, it hurt me. I said, "Oh, wow, all of these brothers and ancestors who have to operate as if they are invisible men, in the words of Ralph Ellison; they have to work serving people who act as if they're not even there." I was hurt and then, all of a sudden, God tapped me on the shoulder and said, "OM3, I have a message for you. I want you to tell everybody at Trinity that you received a word from the movie *The Butler*. The butler was in the room, but people acted as if the butler wasn't there. It got to the point where they didn't even see the butler, yet the butler kept blessing everybody in the room. Although they couldn't see the butler, the butler was still blessing everybody in the room. Even though they didn't know the butler was there, the butler kept blessing everybody in the room."

You may not see God moving in your life, but God's in the room. For every blessing, for every healing, for every movement, for every shift, you need to know that God is in the room. And if you have forgotten to thank God, you need to repent today and say, Lord, I'm sorry for not acknowledging your blessings. I'm sorry for not acknowledging that you are in the room. On this day, this "Gospel according to *The Butler*" day, we want to thank Jesus and we want to thank God. We want to thank the Holy Spirit.

We need to thank people who were connected to God before we were connected to God. Those unsung heroes who, as a result of their work, paid for your school, kept you out of jail, put food on your table, a roof over your head, and clothes on your back, wiped tears from your eyes, changed your diapers, put lotion on your ashen legs, did all of that. You need to thank God for hairdressers who blessed your life. Thank God for postal workers who blessed your life. Thank God for maids who blessed your life. Thank God for teachers who blessed your life. Thank God for bus drivers who blessed your life. Thank God for cooks who blessed your life. Thank God for seamstresses who blessed your life.

Thank God for midwives who blessed your life. Thank God for sharecroppers who blessed your life. Thank God for waitresses who blessed your life. Thank God for Pullman porters who blessed your life. You need to thank God for those butlers who were invisible in the room but who made a way for you so that you could be where you are right now. "The gospel according to the butler" says that you receive joy when other people succeed. It means that you bring value to the work that you do.

QUESTIONS FOR REFLECTION

1. What are the elements of a "butler spirit"? Do you possess any of these elements? How do you share your gifts with others?

2. The phrase "Uncle Tom" is based on a character in Harriet Beecher Stowe's 1852 novel, *Uncle Tom's Cabin*, set in the pre–Civil War South. The novel contrasts heroism and subservience during slavery. The term has become derogatory when applied to African Americans. What other images does the preacher put forth for that of "Uncle Tom"?

3. Purah was Gideon's armor bearer, tasked with protecting him in battle. How did Purah support Gideon psychologically and spiritually? Who has been your armor bearer? How has that person supported you? For whom are you an armor bearer and what do you provide?

4. The preacher lifts up Joseph, Saul, and David as leaders who first served in the shadows. In what ways do you embody servant-leadership?

5. Who are the unsung heroes and heroines in your life? In the life of your community? How can you honor them?

AFTERWORD

Cinema is a matter of what's in the frame and what's out.

❀

—MARTIN SCORSESE

Martin Scorsese, one of the greatest living American directors, gives us a simple window to understand the power of cinema. What is in the frame is a choice by the filmmaker and what is not highlighted is also a choice.

People of color, literally and metaphorically, have struggled to be included in the frame and fought to move from the background to the foreground of the cinematic imagination.

American cinema, historically, has been the vanguard of stereotypes and the enforcer of our racialized imagination. Our view of women, people of color, and ethnicities define and are expanded by the power of cinema.

Hollywood, since the release of *The Birth of a Nation*, the revisionist history of the Civil War and Reconstruction, defined the Ku Klux Klan as the hero of the story and used white actors in blackface to

frame black people as a threat to white society. This film, while not seen by the majority of filmgoers, set into motion the racial constructs we now view as normative. Black men, for example, have been viewed in cinematic history as ethically dubious, highly sexualized, violent, or childlike comic characters.

This stereotype created by the filmmaker's imagination became, in the minds of many Americans, a historical fact. Cinema helped reinforce myths and arbitrary prejudices based not on cultural differences, but on protecting economic interests of white Southerners who feared black labor.

When a film seeks to break this colonized cinematic imagination, the filmmaker and the audience take a risk. The financial risk is the rejection of the work by the "mainstream audience" and the rejection by critics for not being "real and authentic." I mentioned being "real and authentic," because black films carry the unfair double weight of proving they are financially viable and are "authentic" depictions of black life. Valerie Smith calls this the "documentary impulse" in black film.* It should be noted that Woody Allen, Ron Howard, Barry Levinson, or Martin Scorsese have never been told to stop making films because of a box office flop. Filmmakers of color and women are routinely categorized as too risky if one film fails to reach profitability. I should also add that Woody Allen has only created one mainstream hit in his amazing career, but he is consistently financed as an art house director.

Black film is not only unfairly scrutinized during the preproduction phase, but is asked, "Is this film real and authentic to black life?" When Spike Lee produced his cinematic masterpiece, *Do The Right Thing*, critics, many white and middle class, claimed the film did not have enough "drug use" to accurately portray black life. Several

*Valerie Smith, "The Documentary Impulse in Contemporary African-American Film," in *Black Popular Culture: A Project by Michele Wallace*, ed. Gina Dent (Dia Center for the Arts, 1992), 67.

prominent critics claimed that the riot scene in the film would cause ethically dubious, oversexualized black men to run rampant in the streets of America.

Cinematic myths have damaged our imagination and hurt our ability to view people of color with complexity. With all this cinematic history in tow, the production of *12 Years A Slave*, *The Butler*, *Fruitvale Station*, and *Mandela: Long Walk to Freedom* is all the more fascinating. The black cinematic renaissance we are witnessing is a testament to the changing face of America. For years blacks and Latinos have watched men of mostly European descent define the world through image and sound on the big screen. The changing demographics of America is giving birth to a new audience, not threatened by characters of color and hungry for diverse stories.

I am not suggesting that Hollywood is trying to correct its past wrongs, but the untapped market colliding with talented auteurs has created space for films with a cultural nuance, once absent from the theater. For instance, the film *The Butler* shines a light on a little known aspect of American history, the dignified working class, who sacrificed to make life better for the next generation. *The Butler*, with all the historical characters, is nothing more than a story of a father and a son attempting to find meaning and space in the world. *Fruitvale Station*, a film, on the surface, about a brazen act of injustice, is a story of a young man, flawed but very human, who has dreams and desires that are cut short by the virus of racism affecting our nation. The film *12 Years A Slave* dares to show a black man loving his wife and children against the backdrop of America's greatest sin—chattel slavery. All of these films share a vision of America hidden from view by the veil of race that has been supported by cinema. Each film forces the viewer to expand his or her visual vocabulary and dare to see a world beyond traditional roles and stereotypes.

Hollywood is in the business of myth-making and legend creation. It is through myth and stories we find our humanity and dare to dream of a better world. The films of Frank Capra, *It's a Wonderful Life* and

Mr. Smith Goes to Washington, developed the myth of the small town hero endowed with faith and a good heart. The *Rocky* saga created the myth of the working class underdog who, if faithful, could defeat an arrogant physically endowed (and black) champion. *Star Wars* created a spiritual quest myth borrowing from Eastern and Western religious traditions. (It should be noted that only two people of color are represented in this future world.) I for one am glad now that myths and legends are being born and the American imagination is being decolonized by directors who dare to dream of a world beyond European roots.

APPENDIX

12 YEARS A SLAVE

*A Review**

❧

Since the production of *The Birth of a Nation*, directed by D. W. Griffith, Hollywood has lived with the mythic world imagined by artists who view the lives of people of color as footnotes and props. From *Gone With the Wind* to *Django*, the most difficult type of film for Hollywood to get right is the antebellum story of people of color.

Django, for example, used the archetypes designed by Hollywood—the "Toms, Coons, Mulattoes, Mammies, and Bucks"—to quote the title of film historian Donald Bogle's classic critique.** and exploit them in order to create a hyperexploitive Western fantasy, with slavery as the backdrop. The film is a remix and critique of exploitation clichés, not a historical drama seeking to illuminate our consciousness. *Django* is a form of visual entertainment where enlight-

*Otis Moss III, "*12 Years a Slave* Creates New Space for Antebellum Storytelling," Sojourners: Faith in Action for Social Justice, 10-14-13, blog at http://sojo.net/blogs/2013/10/14/12-years-slave-creates-new-space-antebellum-storytelling.

**Donald Bogle, *Toms, Coons, Mulattoes, Mammies, and Bucks: An Interpretive History of Blacks in American Films* (New York: Bloomsbury Academic, 2001).

enment might happen through a close reading of the film. All the archetypes remain in place. Nothing is exploded or re-imagined, only remixed to serve the present age.

Steve McQueen's *12 Years A Slave*, on the other hand, sits within and outside the Hollywood fantasy of antebellum life. I say it sits *within* because the archetypic characters forged by the celluloid bigotry of Griffith are present. But in the hands of the gifted auteur Steve McQueen, they are obliterated and re-imagined as complex people caught in a system of evil constructed by the immorality of markets, betrothed to mythical, biological, white supremacy.

The film dares to tell a story America has been reluctant to share and Hollywood has consistently re-imagined as a whimsical romantic era of comical slaves, noble men, and appropriate women. What is so astonishing about *12 Years A Slave* is the skill with which McQueen navigates the horror with the complex humanity of Solomon Northup's character, played brilliantly by Chiwetel Ejiofor.

The film tells the real life account of Solomon Northup, a free African living in Saratoga, New York. As a family man making a living as a violinist, he is lured away to Washington, D.C., to perform for several days. He becomes deathly ill after a meal with his benefactors and wakes up in chains. He is then eventually sold to a plantation in Louisiana. Northup's ordeal is heart-wrenching, and the brutality we witness through his eyes causes the viewer to reevaluate everything about antebellum lore.

McQueen uses the camera and setting as a character. We feel the pain of each beating and subtle act of cruelty. There are no cinematic gymnastics, quick cuts, only steady, slow-framed shots, where we witness the brutality from the perspective of the oppressed.

One subtle area of the film I was taken by was the use of language. McQueen made the conscious choice to cast British, American, and African actors. This choice gives weight to the production, but not for the reason many would suspect. McQueen's using actors from different regions gives the accents of characters from New England to

Louisiana an authentic feel. Hollywood and America, in general, fail to recognize the diversity and beauty of African-inspired dialect. Northup's character and Ejiofor's pronunciation fit perfectly for a person living in New York influenced by British and colonial communication. Michael Fassbender and Lupita Nyong'o both speak with a communication style influenced by French and African people. McQueen's film is devoid of the stereotypical Hollywood accents popularized by *Gone With the Wind*. We witness men and women rooted in a region who speak with dignity and rhythm. Black dialect, when spoken properly, as playwright August Wilson demonstrates, is a thing of beauty when given the proper context.

No film supported by Hollywood has dared share this American story from the perspective of the enslaved African. Films such as *Goodbye Uncle Tom, Mandingo*, and *Django* use exploitative stereotypes to send a message but ultimately fail because they solidify the celluloid stereotypes composed by D. W. Griffith and others. Movies such as *Amistad* and *Glory* placed people of African descent as props who needed the moral courage and enlightened intellect of a white character to truly set them free. McQueen refuses to engage the paradigms and subtly creates a new space for antebellum story telling. Even the most liberal characters are infected by the evil of racialized thinking and subconscious actions motivated by a belief in white supremacy.

I plan to view the film again and rent a theater for my church to watch and learn. We will have panel discussions and lectures, and our Confirmation class will read the story of Solomon Northup.

Steve McQueen, writer John Ridley, and producer Brad Pitt are to be commended for bringing a portion of our country's history to the screen. I think our ancestors are grateful. I know I am.

Other related books from The Pilgrim Press

PREACH!
The Power and Purpose behind Our Praise
OTIS MOSS III AND OTIS MOSS JR.
FOREWORD BY ANDREW YOUNG
ISBN: 978-0-8298-1907-6 / paper / 128 pages / $16.00

Dynamic father-son preaching team Otis Moss, Jr. and Otis Moss III share their sermons on social justice and other progressive Christian topics in this interactive book. Read each sermon, then scan the code at the end of each chapter to download and listen to the sermon. Topics include: "God Loves the Lost," "The Greatest Invitation: RSVP," "From Moses to Joshua," and more.

THROUGH A DIFFERENT LENS
Revealing the Transformative and Spiritual Power in Movies
CARMEN LEAL
ISBN: 978-0-8298-1973-1 / 144 pages / paper / $17.00

Leal highlights the powerful, redemptive themes found in nine well-known movies, including: *The Wizard of Oz, Mr. Holland's Opus, Hugo, Akeelah and the Bee,* and more. Biblically based chapters are intertwined with real-life stories and scripture and contain well-planned discussion guides that are sure to spark lively group study sessions. Also makes a thought-provoking and spiritually fulfilling personal study.

GIRLFRIENDS
Exploring Women's Relationships in the Bible
BARBARA J. ESSEX
ISBN: 978-0-8298-1954-0 / 128 pages / paper / $14.00

This book from bestselling author Essex explores famous female relationships in the Bible; connects them to popular TV shows, movies, and books; and celebrates the relationships women form with each other. Biblical women discussed in the book include Sarah and Hagar, Leah and Rachel, Mary and Elizabeth, and more. TV shows include *The Golden Girls*, and *The Color Purple* and *Thelma and Louise* are among the featured movies. Fun and engaging, perfect for a "girls night" or women's study group.

THE BOOK OF JEREMIAH
The Life and Ministry of Jeremiah A. Wright Jr.
SUSAN WILLIAMS SMITH
ISBN: 978-0-8298-1935-9 / 320 pages / paper / $20.00

Wright will forever be linked to the historical 2008 presidential campaign of then Senator Barack Obama. Although he was unwillingly thrust into the spotlight, the media attention could never overshadow Wright's prophetic messages of liberation and justice, nor does it define his life and ministry. This book examines the man: an African American, a patriot who served his country, a scholar, a prophet, and a pastor. It sheds light on Wright's upbringing, teaching, and preaching influences—which extend far beyond his pastorate—and the far-reaching effects of his ministry on Obama and the world.

THEY LIKE TO NEVER QUIT PRAISIN' GOD
The Role of Celebration in Preaching
Revised and Updated
FRANK A. THOMAS
ISBN: 978-0-8298-1978-6 / 192 pages / paper / $16.00

Revised and updated edition of a popular preaching resource. According to Thomas, preacher and professor, all good preaching has strong elements of celebration, which is the genius of African American preaching. He has explored this rich tradition and shares his findings to empower students and preachers to transform the impact of their preaching. Includes new sermon illustrations, strategies, and more.

THOSE SISTERS CAN PREACH!
22 Pearls of Wisdom, Virtue, and Hope
VASHTI MURPHY MCKENZIE, EDITOR
ISBN: 978-0-8298-1984-7 / 144 pages / paper / $15.00

A remarkable collection of sermons from twenty-two highly esteemed African American women preachers. Edited by Vashti Murphy McKenzie, best-selling author and first female bishop in the African Methodist Episcopal (AME) Church. Each sermon includes corresponding scripture(s) and addresses issues Christian women face. Titles include: "It's a Set-Up," "What You Have . . . Is More Than Enough," "Cut It Off and Cut It Loose," "Push Past Your Pain," and more. Will inspire a new generation of prophetic female voices.

I REFUSE TO PREACH A BORING SERMON
Engaging the 21st Century Listener
KARYN L. WISEMAN
ISBN: 978-0-8298-1956-4 / 128 pages / paper / $17.00

One of the reasons preachers give boring sermons, says Wiseman, is because they haven't moved into the modern world and connected with their members. Here she shares many insights and strategies gleaned from years of experience teaching courses in homiletics, liturgical studies, and worship. Preachers will learn how to make their sermons come alive with social media, narrative techniques, technology, imagery, and imagination. Each chapter includes a "Things to Try on Your Own" section.

To order these or any other books from The Pilgrim Press call or write to:

THE PILGRIM PRESS
700 PROSPECT AVENUE EAST
CLEVELAND, OH 44115-1100

Phone Orders: 1-800-537-3394 · Fax Orders: 216-736-2206

Please include $6.00 shipping charge for first book and $0.75 for each additional book.
Or order from our websites at thepilgrimpress.com or uccresources.com.
Prices subject to change without notice.